HOMECOMING
A Collection of Art

By
JERRY L. WEEMS

Copyright © 2014 by Jerry L. Weems. 551898

ISBN: Softcover 978-1-4931-7155-2
 EBook 978-1-4931-7156-9

All rights reserved. No part of this book may be reproduced or transmitted in any form or by any means, electronic or mechanical, including photocopying, recording, or by any information storage and retrieval system, without permission in writing from the copyright owner.

Rev. date: 05/15/2014

To order additional copies of this book, contact:
Xlibris LLC
1-888-795-4274
www.Xlibris.com
Orders@Xlibris.com

My art work is a reflection of childhood memories of growing up in the deep Jim Crow south (Mississippi) in the 1960s. The Vietnam war was raging on as the Civil Rights Movement was in full swing. I grew up in a large family with a sister, three brothers and lots of cousins and friends to play with. It was always a joyous time around the house. It was filled with plenty of laughter, singing and good times. We did not have a television set in those days, so during cold winter nights, my uncle would give us drawing lessons, as we sat around the warm wood burning stove drawing on brown paper bags. My uncle was a very good artist and my first art teacher. My grandmother had an old bible that was tattered and worn; but was filled with great beautiful biblical paintings. These paintings really captured my imagination. Every night I would flip through the bible, one page at a time, until I found the picture I wanted to draw. I became so skilled at replicating those pictures that I was often accused of tracing them. I decided then that if people thought my drawing was that good, I could tell my own story through my art work.

I consider myself a visual story teller, highlighting the stories of people and places that have had a significant impact on African-American life today. My paintings are a narrative of my life, paying tribute the many lives of countless African-Americans who lives were often unappreciated during their time. I seek to glorify their existence, presenting them as strong, proud and empowered while also illuminating their plight and showing their pain; their joy together. As an artist I feel that it is incumbent upon me to tell my story: my African-American experience. And in so doing I am telling the story of the many voiceless, unsung heroes who gave their lives because they refused to submit to the whims of the oppressor.

FOREWORD FOR JERRY L. WEEMS

Jerry L. Weems is visual artists that embraces his cultural past yet strives for a better future. He displays within his highly personal painting narratives universal themes of racism, poverty, inequality, hope, joy, and dignity within the African American experience. Originally born in the segregated South of the 1950's, Jerry came of age during the social and cultural upheaval of the 60's and 70's. It is from this period that fused his psyche in creating images that reflected him, and environment around him.

Like young, gifted artists, Jerry had the opportunity to study traditional Fine Arts techniques in painting and drawing at a variety of secondary and higher educational settings. But the most influential teacher that played a dominant role in his painting oeuvre was an Artist/Teacher by the name of Mario Rueda, who was a master figurative painter in Oils. It was under his art tutelage at Los Angeles Trade Technical College that Jerry received a comprehensive/atelier training approach in how to effectively mix colors and master the underlying structures of the human form and objects. Jerry also learned the importance and beauty of painting an image in black and white that emphasizes the true values of forms.

Jerry continued his love of portraiture and figuration as he pursued his Masters degree in painting from Cal State University Los Angeles. It was there that his mature style evolved. He became interested in conveying his deep personal language in painting. No longer was he consumed in replicating realistic/representational images; instead, he look toward art that catered to Folk Art and Assemblage tenants. As a result, he began to paint his forms in an expressionistic, raw or childlike manner on used discarded wood/panel. It is on these panels that he creates his evocative vignettes.

His works convey his deep commitment in displaying positive cultural images that are negated by the dominant culture. As a result of him exploring his unique visions, Jerry is generating an impressive body of works that reveals the psychological layers of working in a Social Realist aesthetic. Yet he still pays reverence/homage to those unsung folk artists that create utilizing the resources and materials at hand.

This continues to be a trait amongst artists of color that fosters the need for self expression. Jerry L. Weems art speaks to the viewer with that same determination and conviction.

Eric T. Myles,
Artist, Friend, and Colleague.

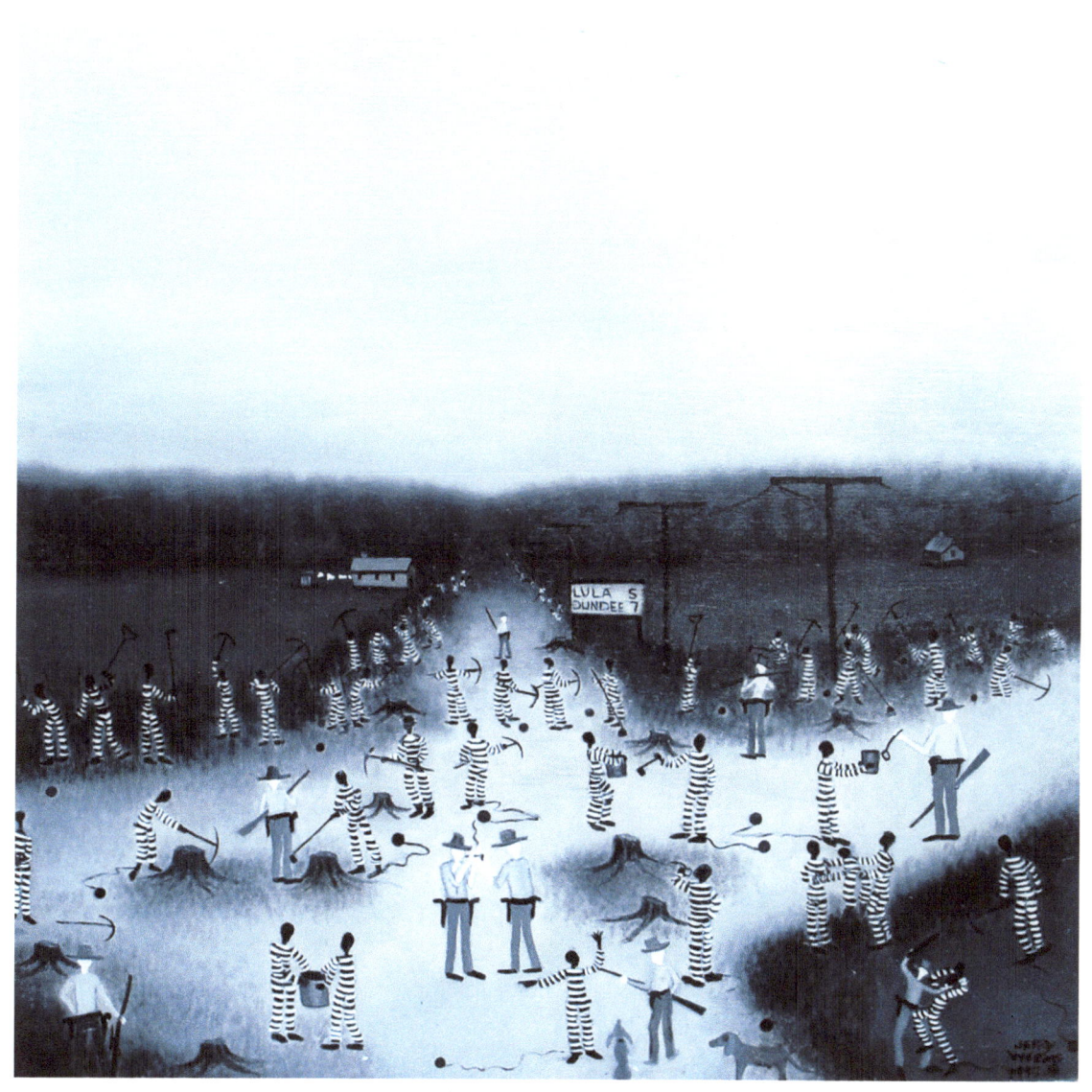

Chain gang 30" x 36" oil on board

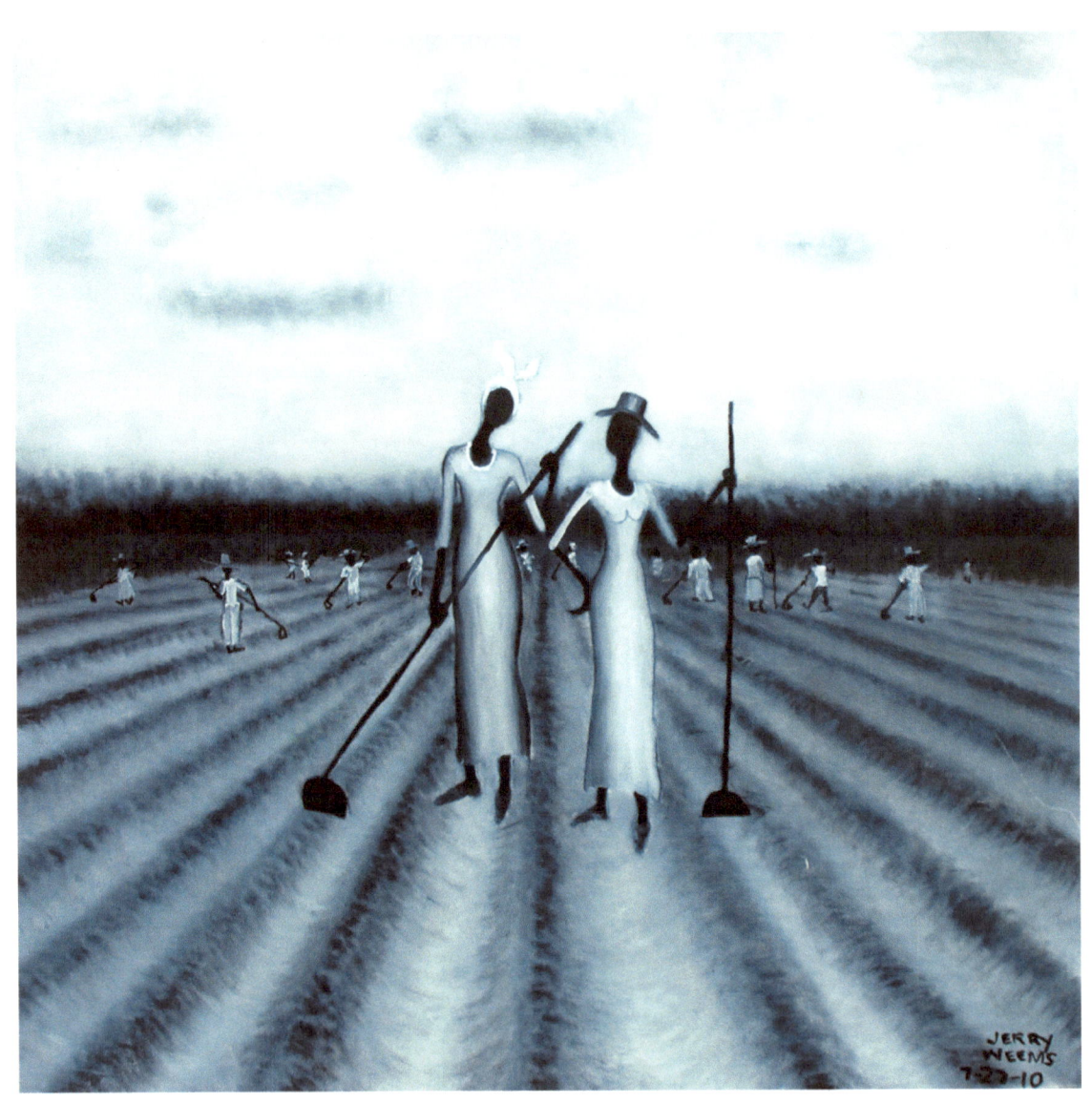

Girl talk 30"x 34" oil on board

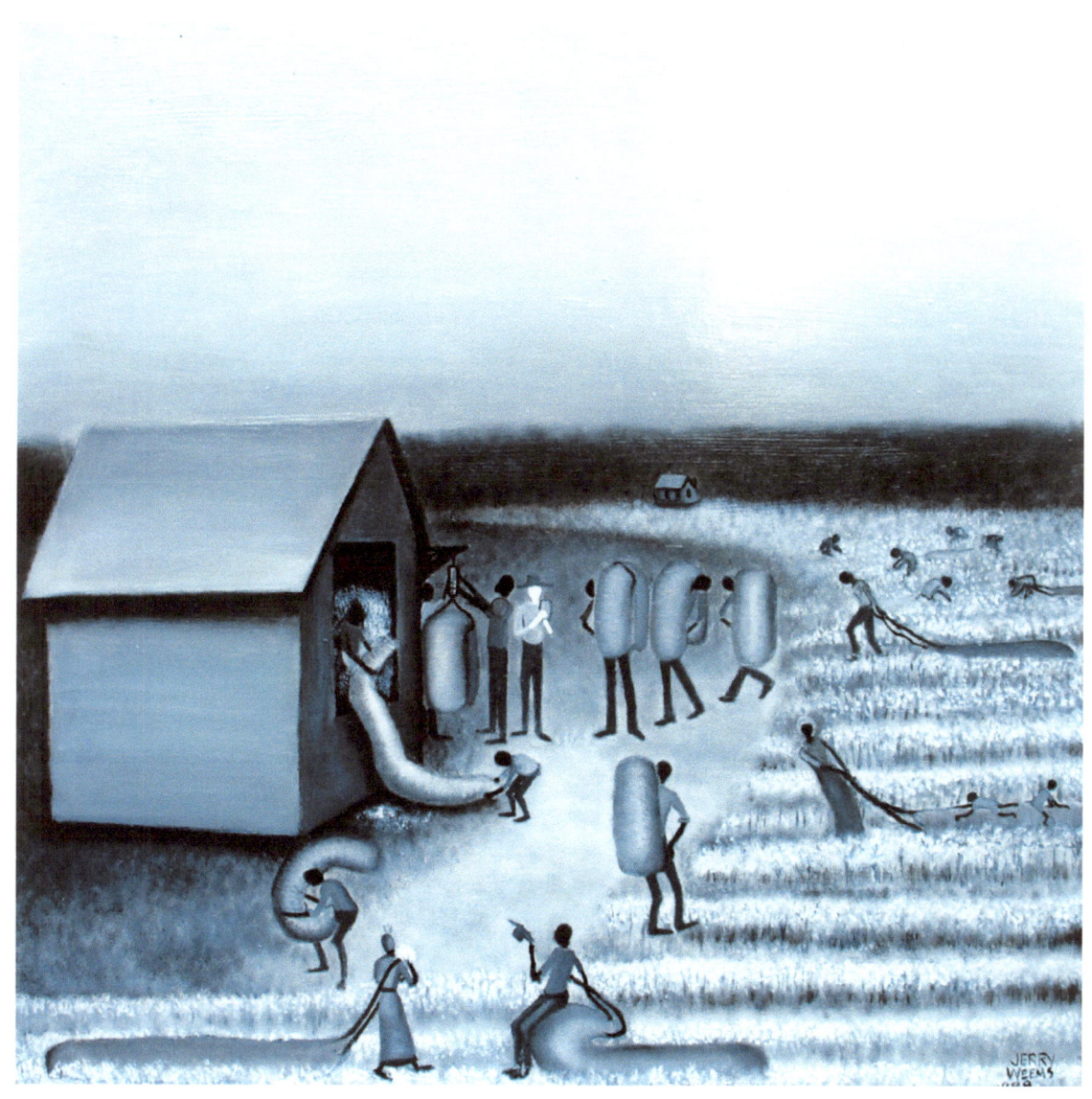

Picking Cotton oil on board 25"x 35"

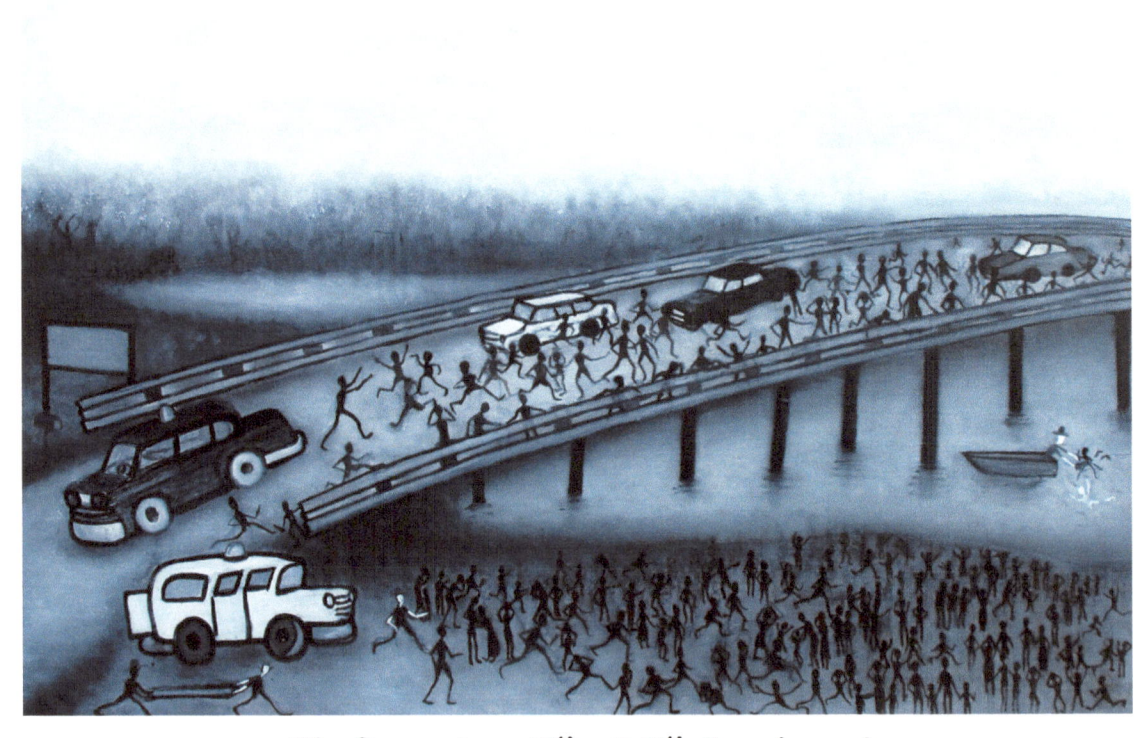

The Drowning 18" x 20" oil on board

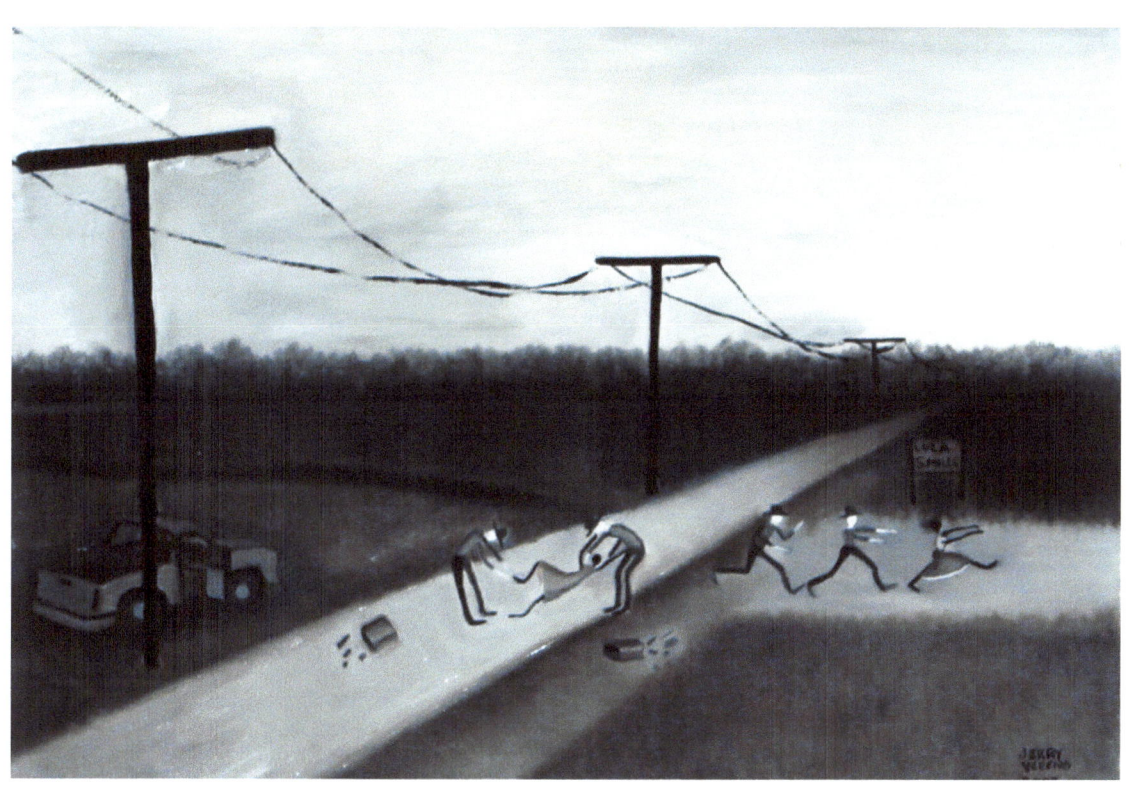

The Chase 18"x20" oil on board

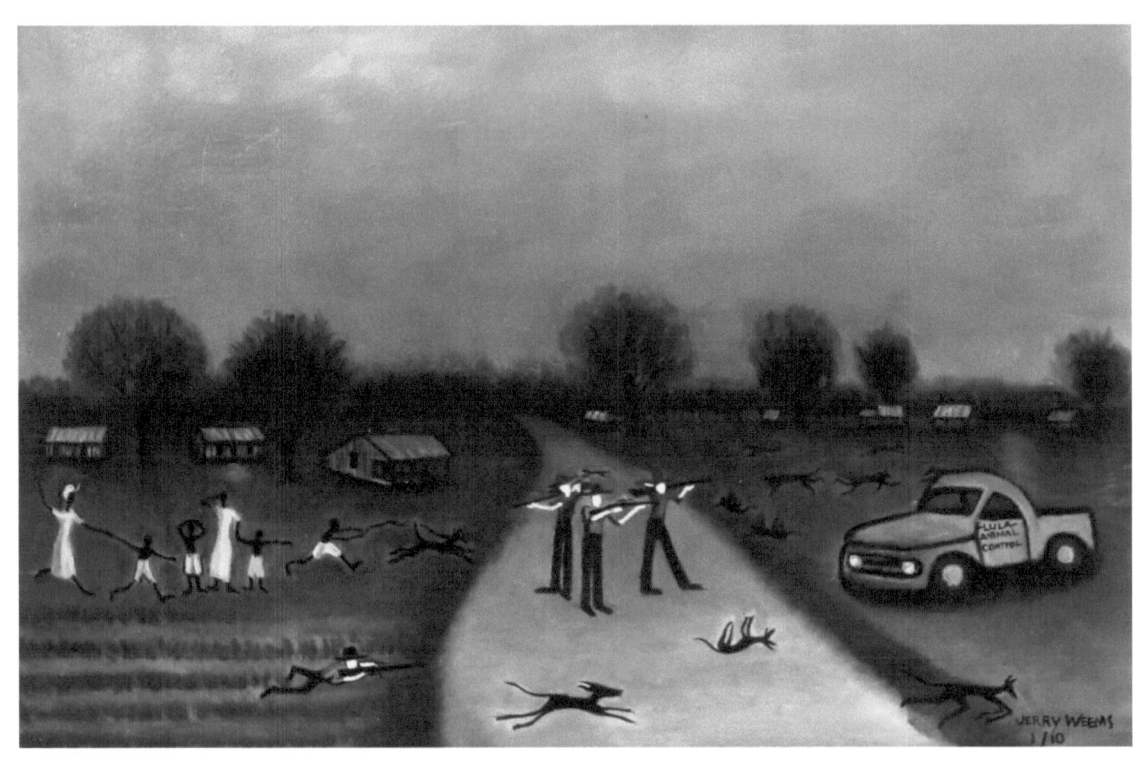

Animal Control 18"x 20" oil on board

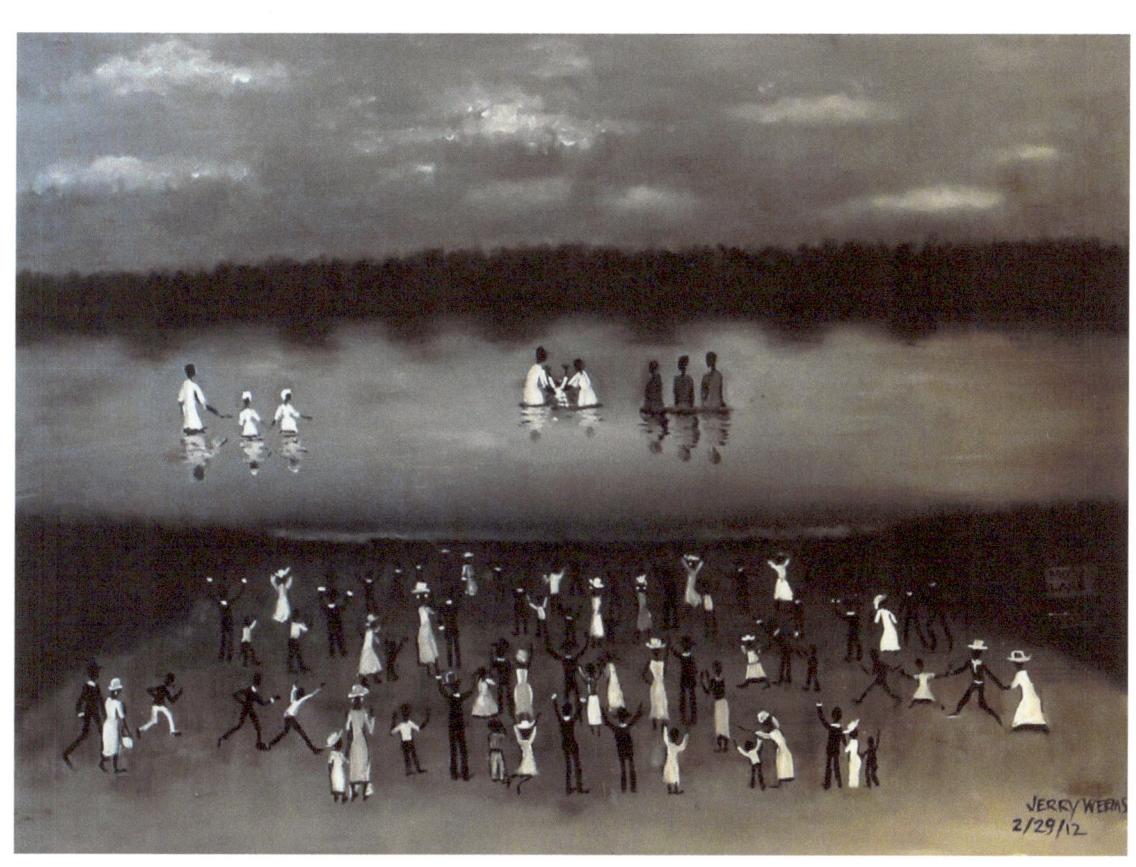

The Baptism 18" x 20" oil on board

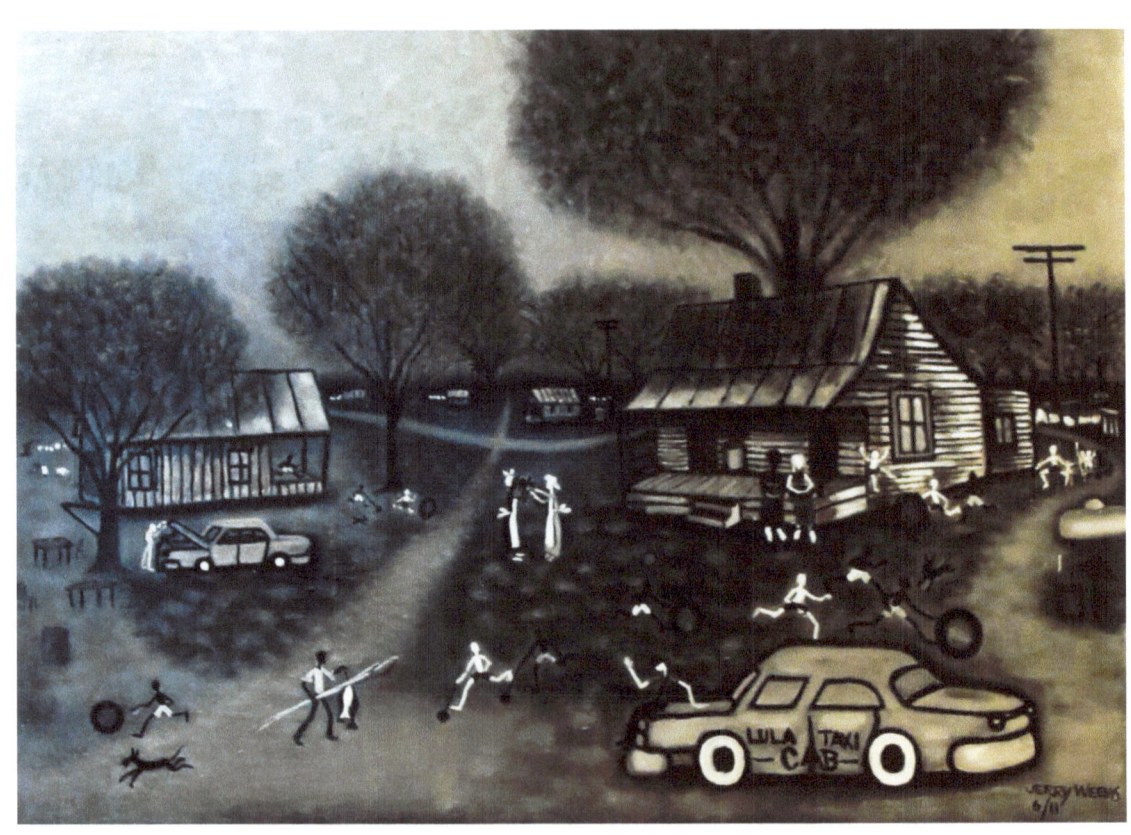

We are neighbors 16"x 20" oil on board

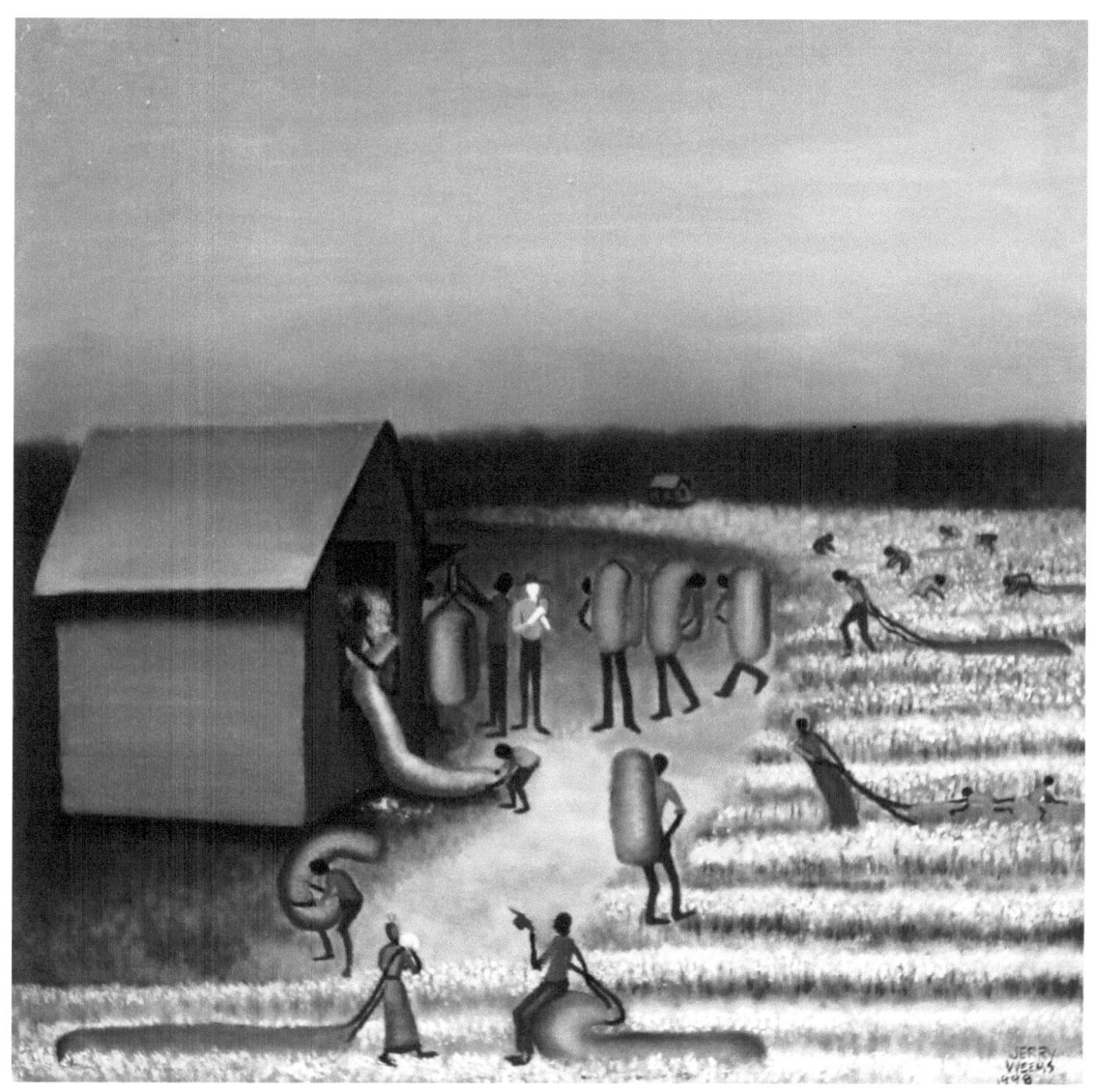

Pick-n-cotton 27"x 32" oil on board

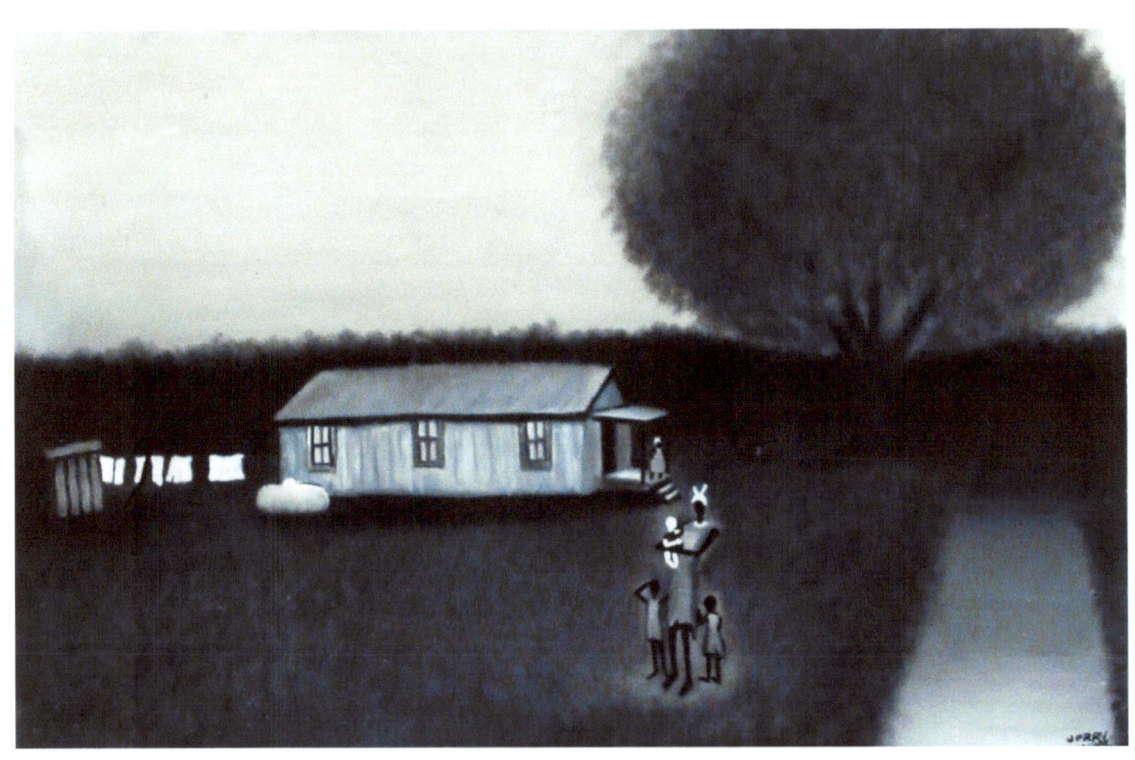

Miscegenation not allowed 16"x 20" oil on board

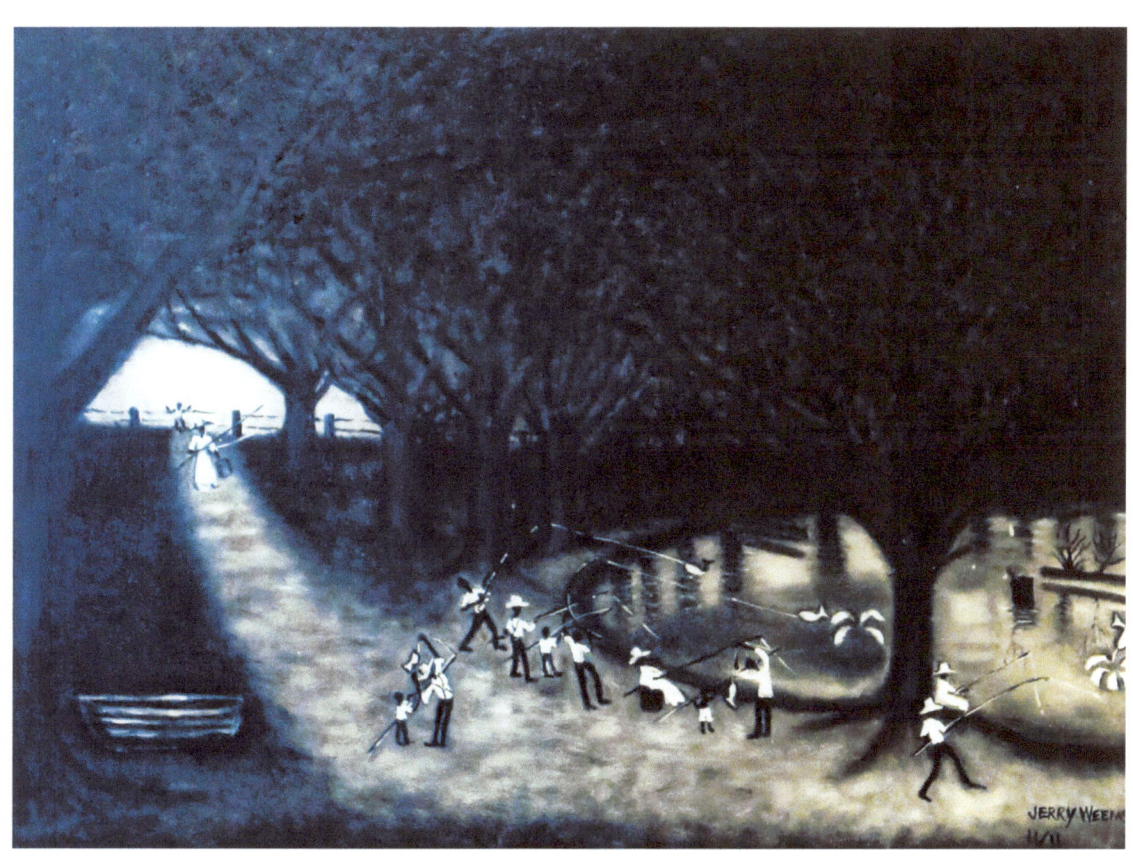

The fishing hole 18" x 20" oil on board

Larry hit that truck 16"x 20" oil on board

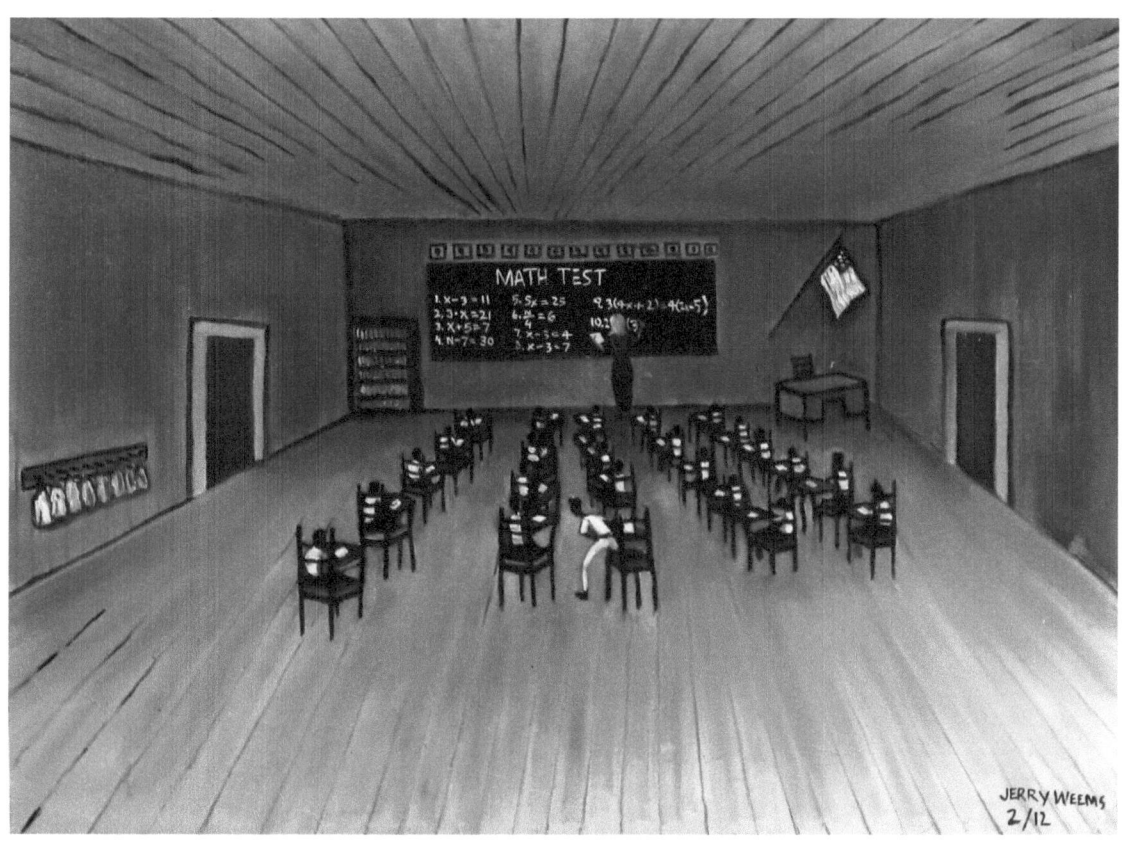

The math test 18"x20" oil on board

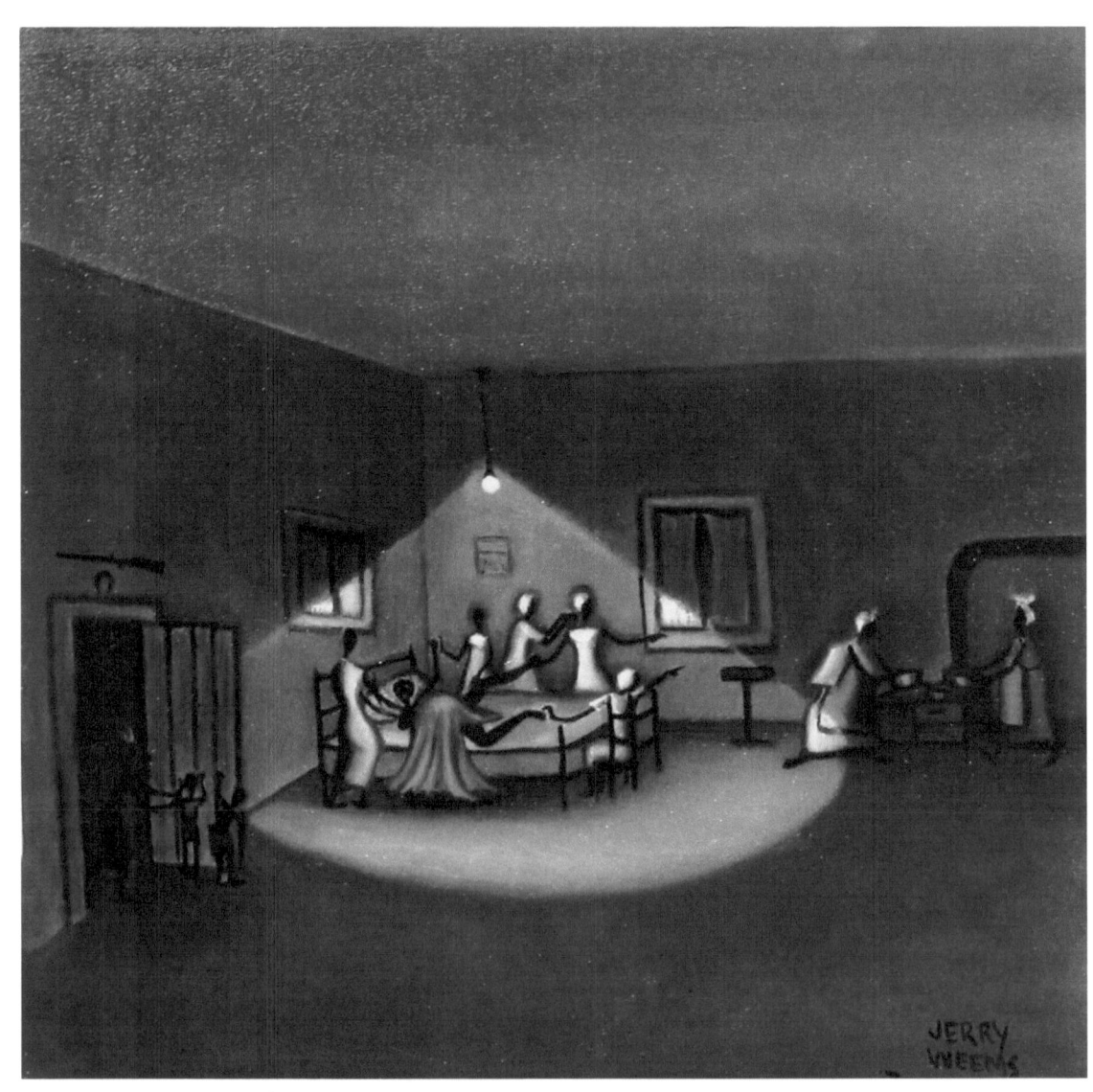

The Midwife 16"x16" oil on board

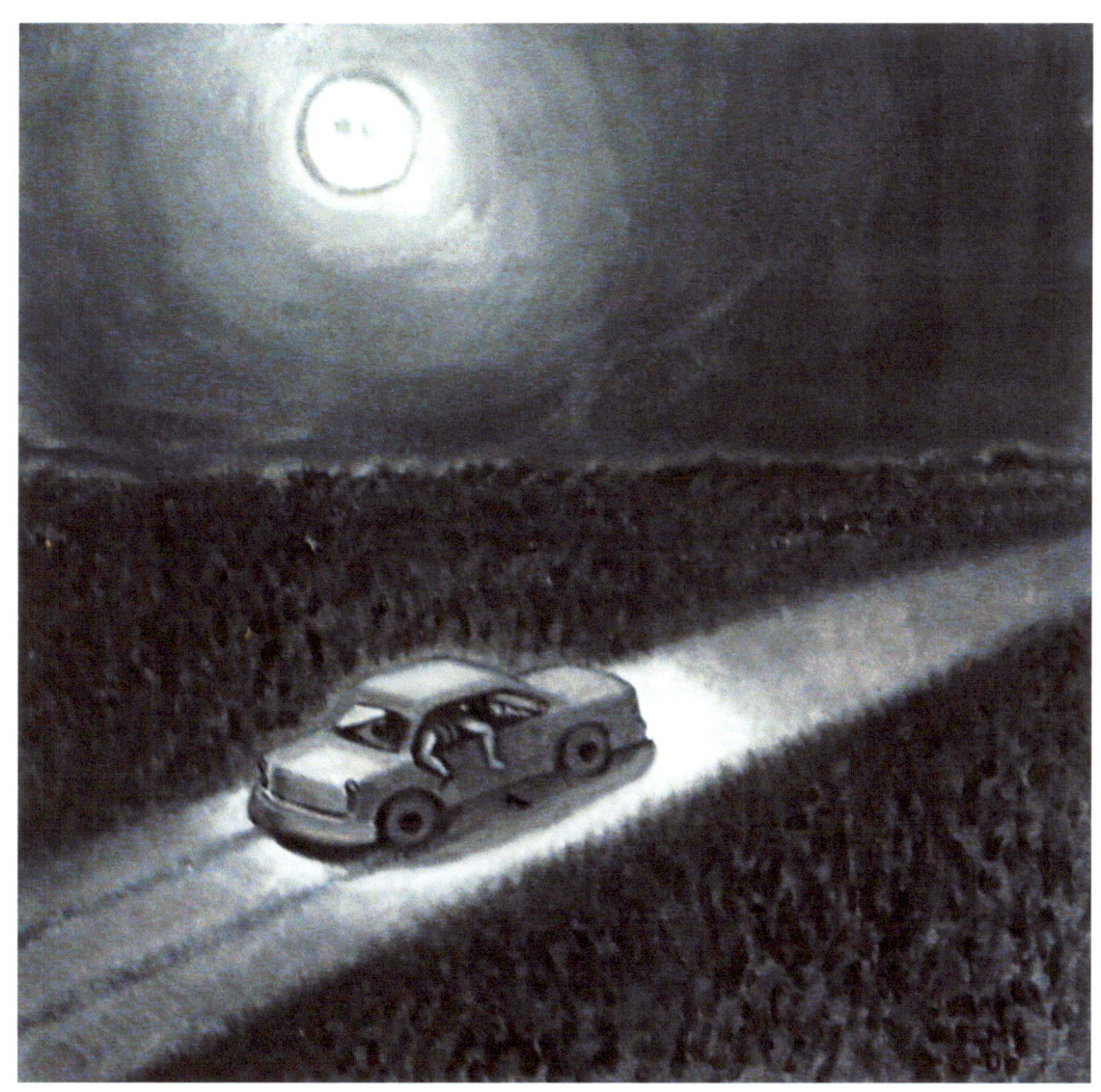

The turn road 16"x16" oil on board

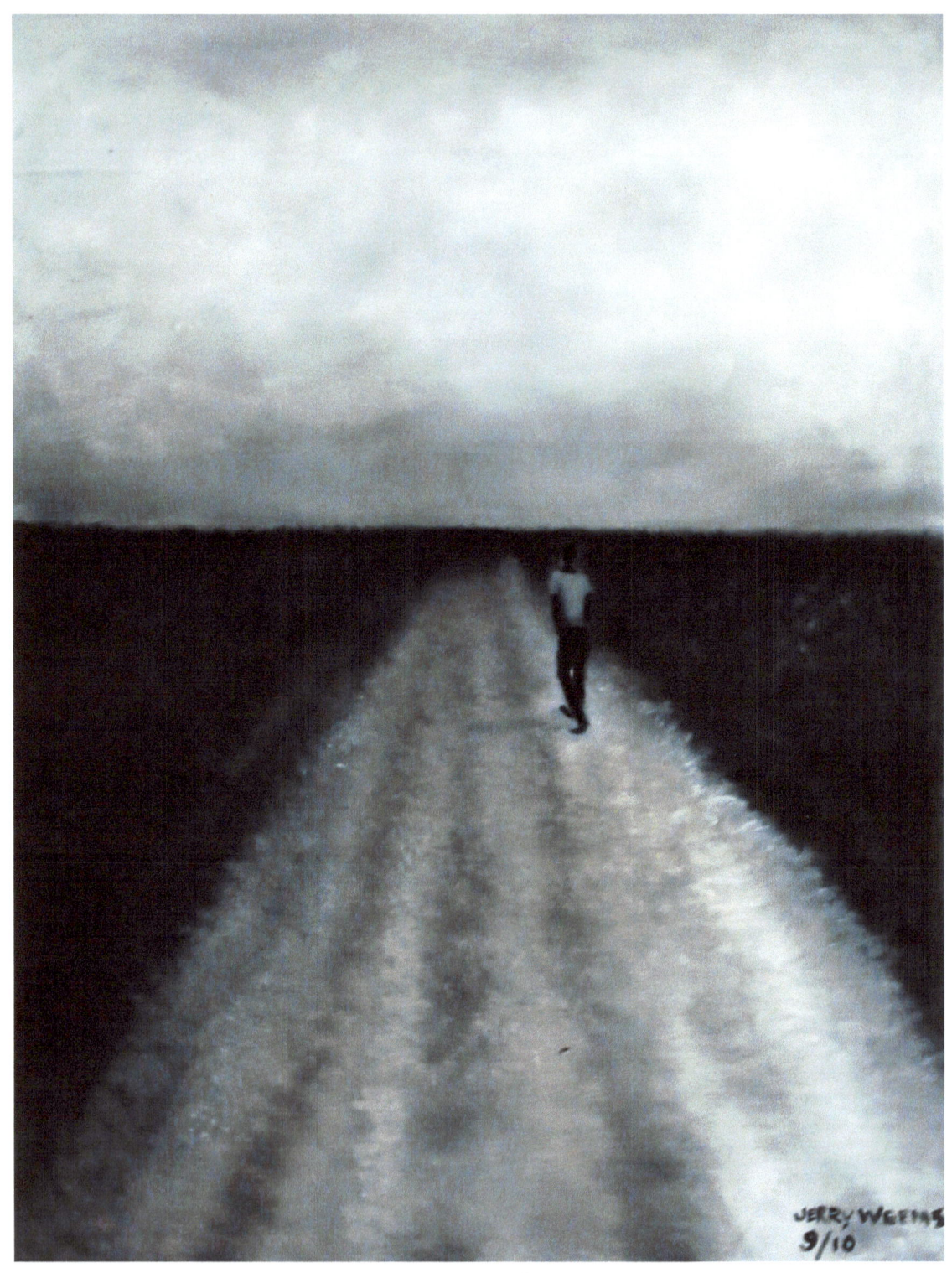

The road long ahead 16"x22" oil on board

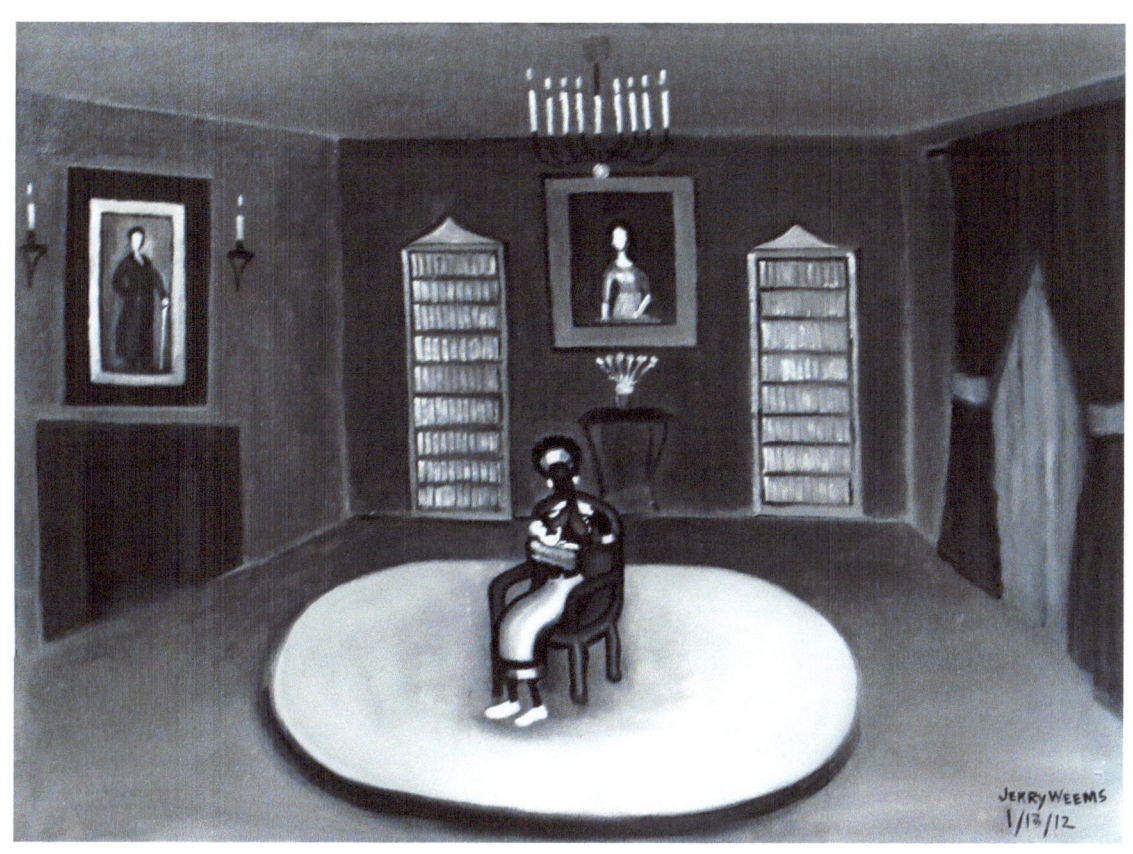

The cleaning woman 18"x20" oil on board

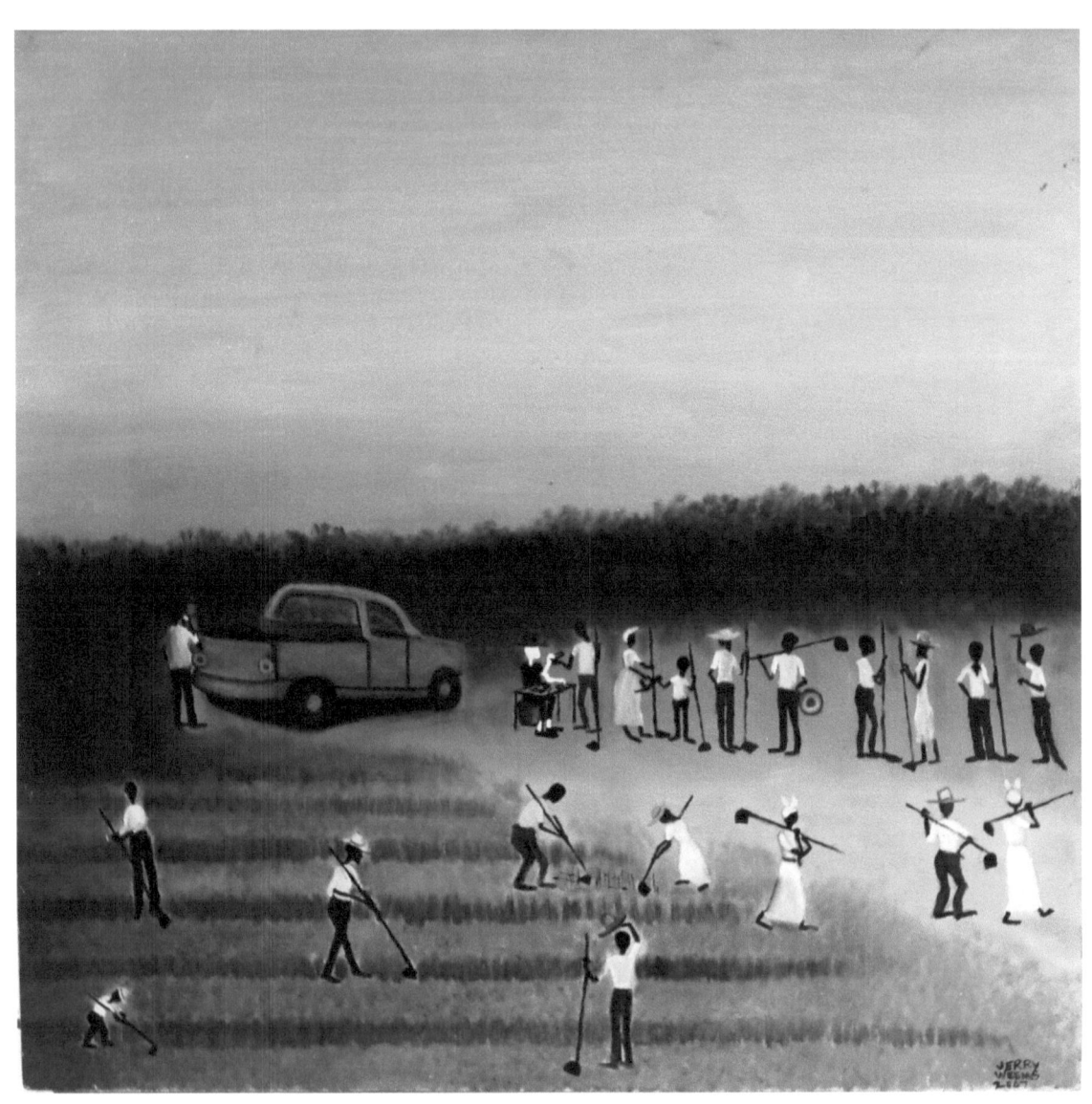

Pay day 20"x 24" oil on board

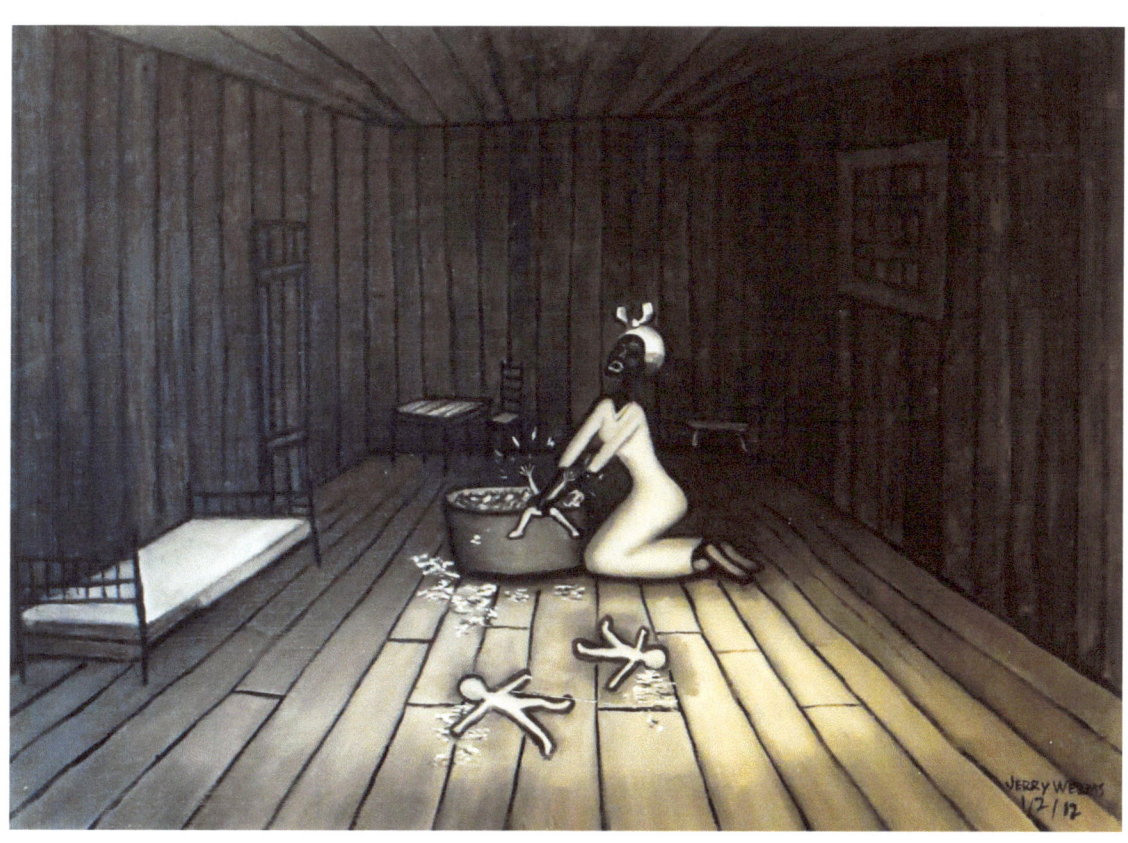

A Form of resistance 16"x24" oil on board

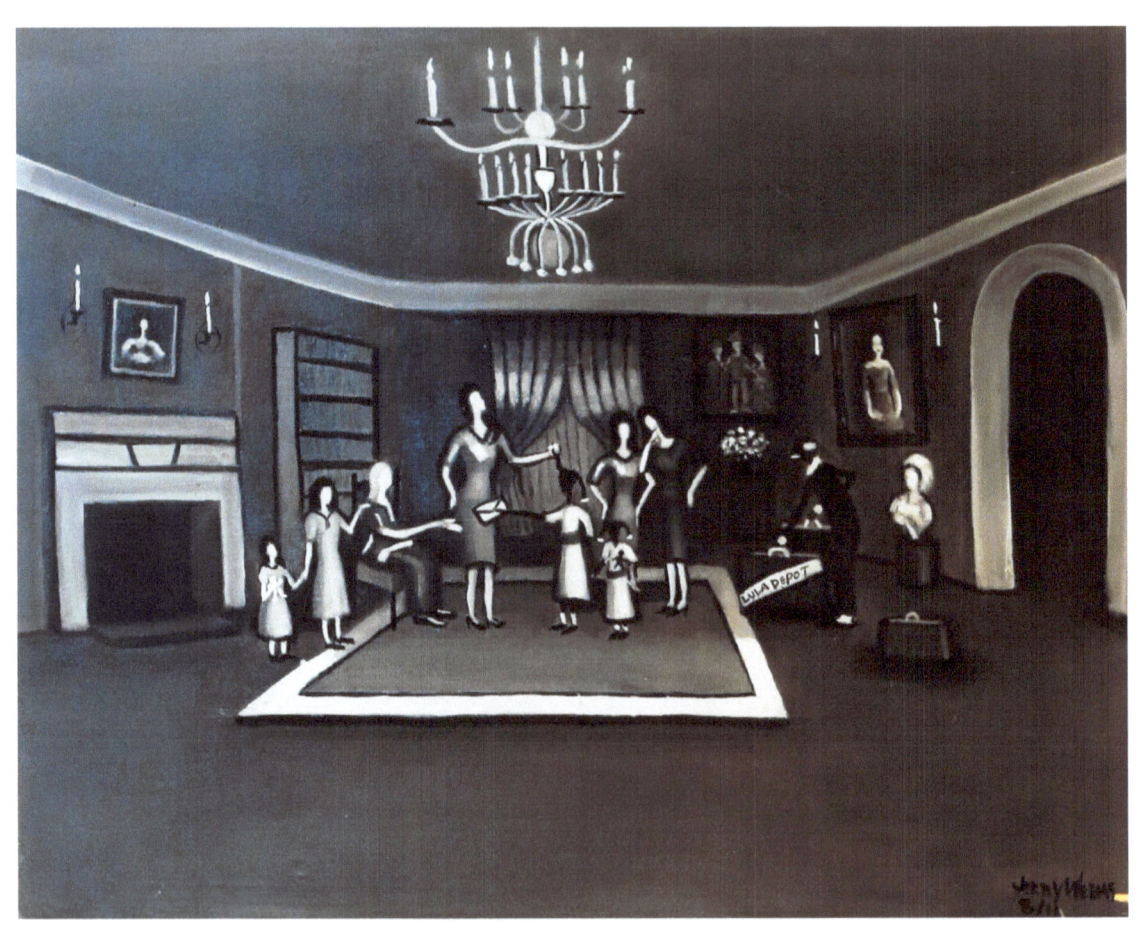
A letter to grandma 16"x24" oil on board

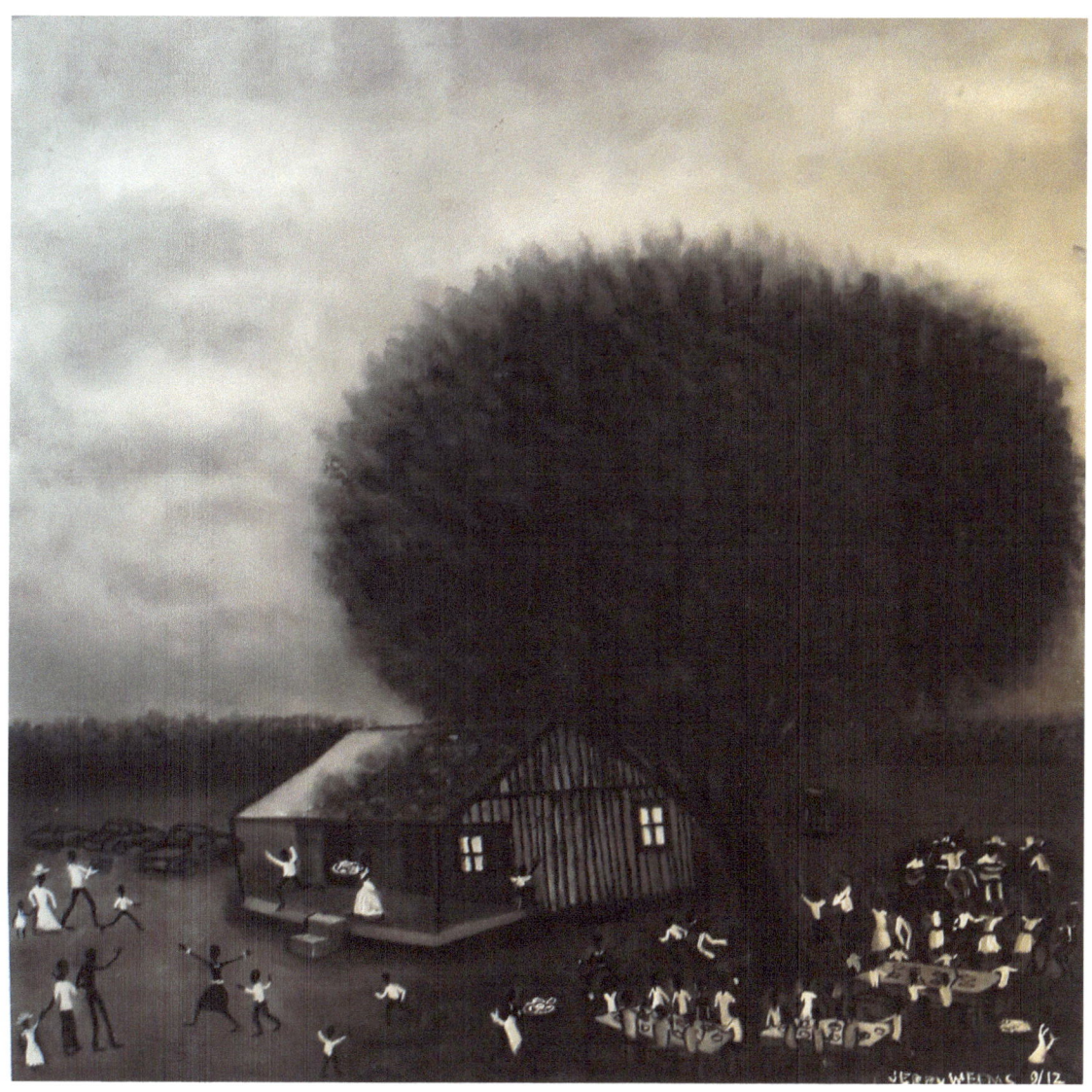

The gathering 18"x24" oil on board

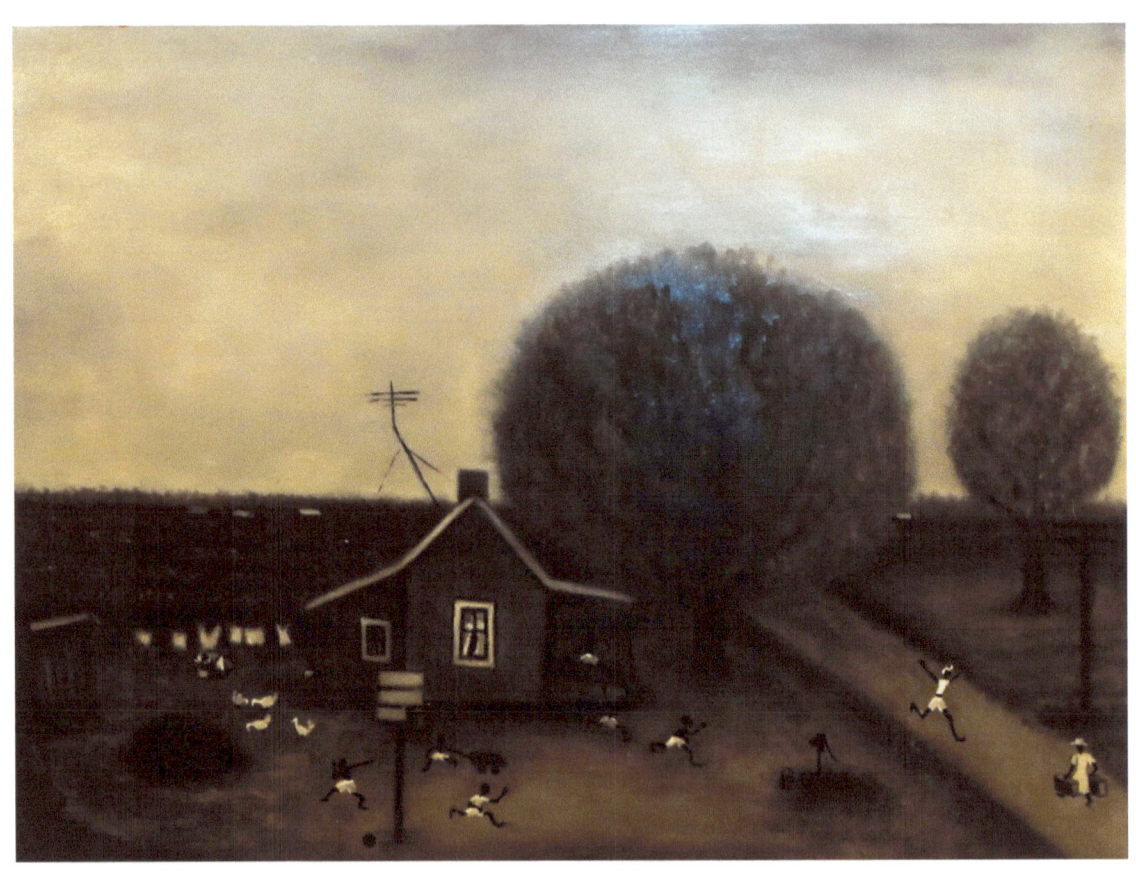

Home coming 24"x30" oil on board

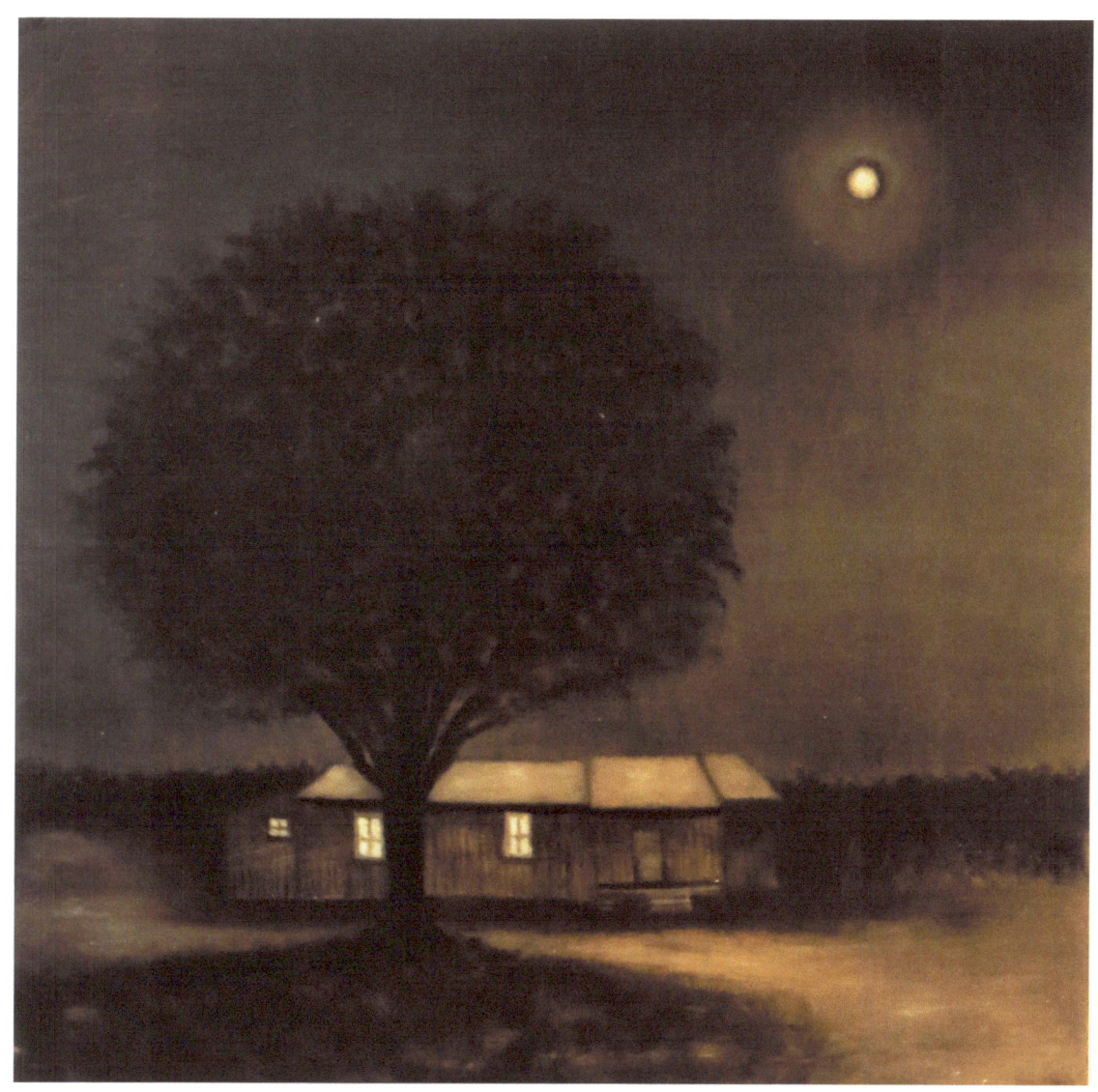

Moon lit night 20"x24" oil on board

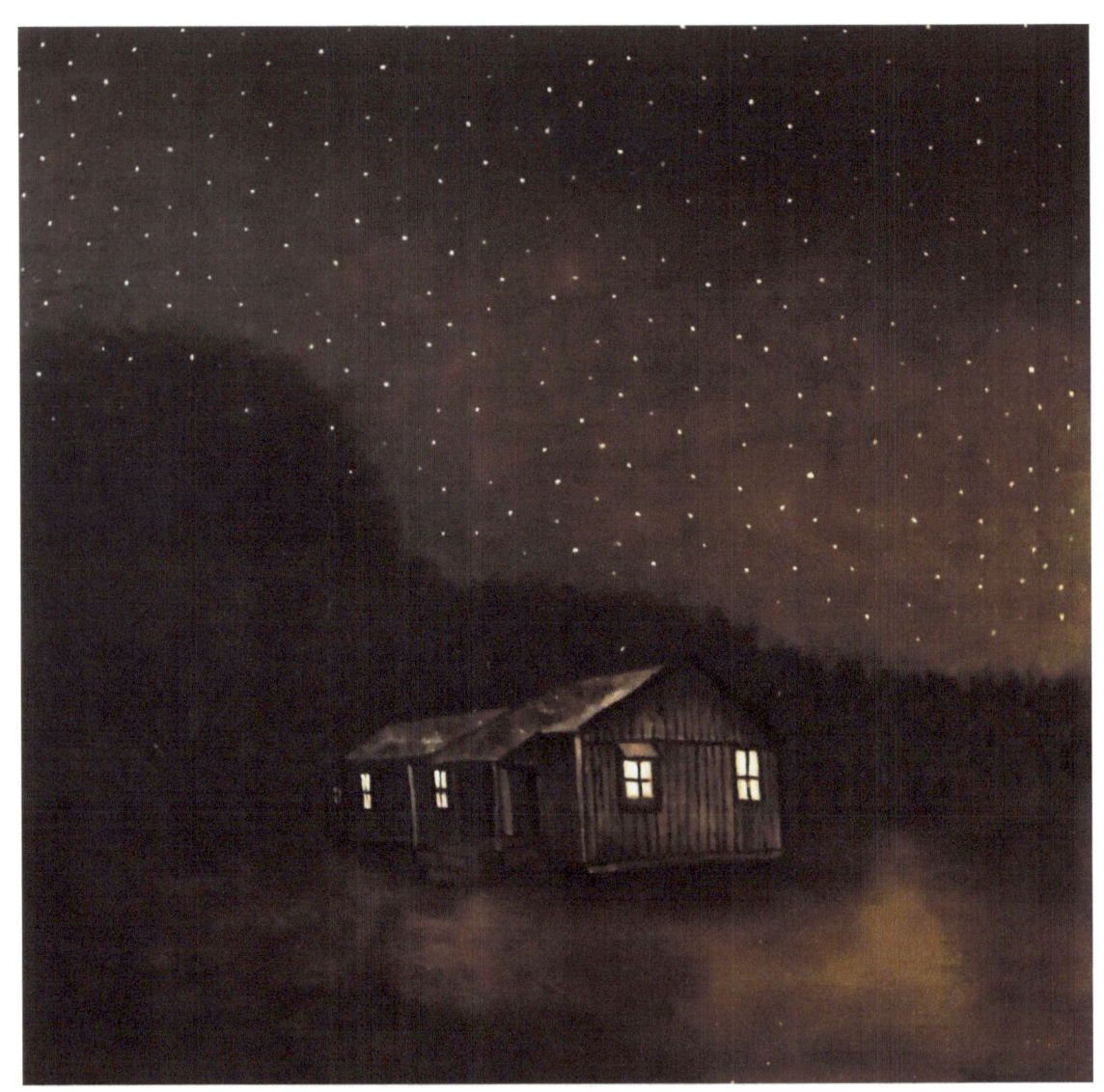

Starry Night 24"x24" oil on board

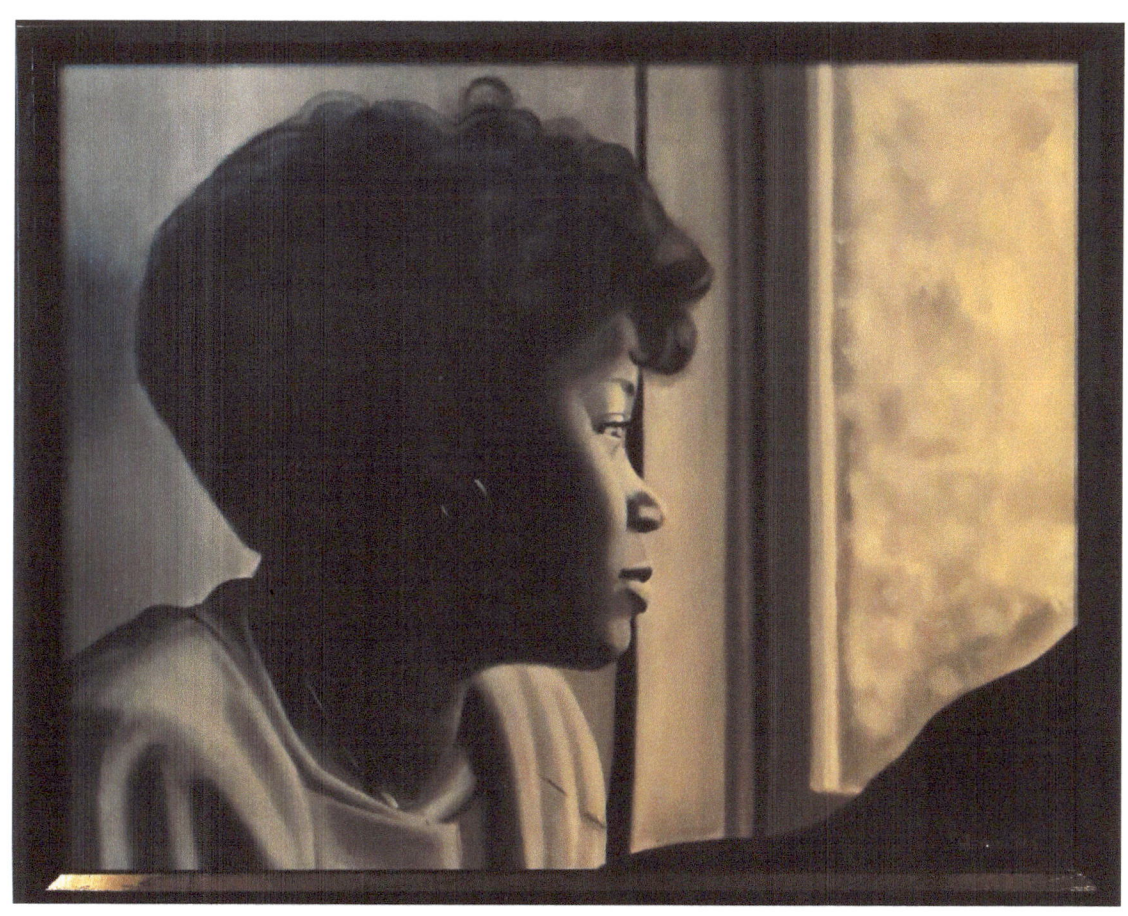

Lost in the moment 32"x36" oil on canvas

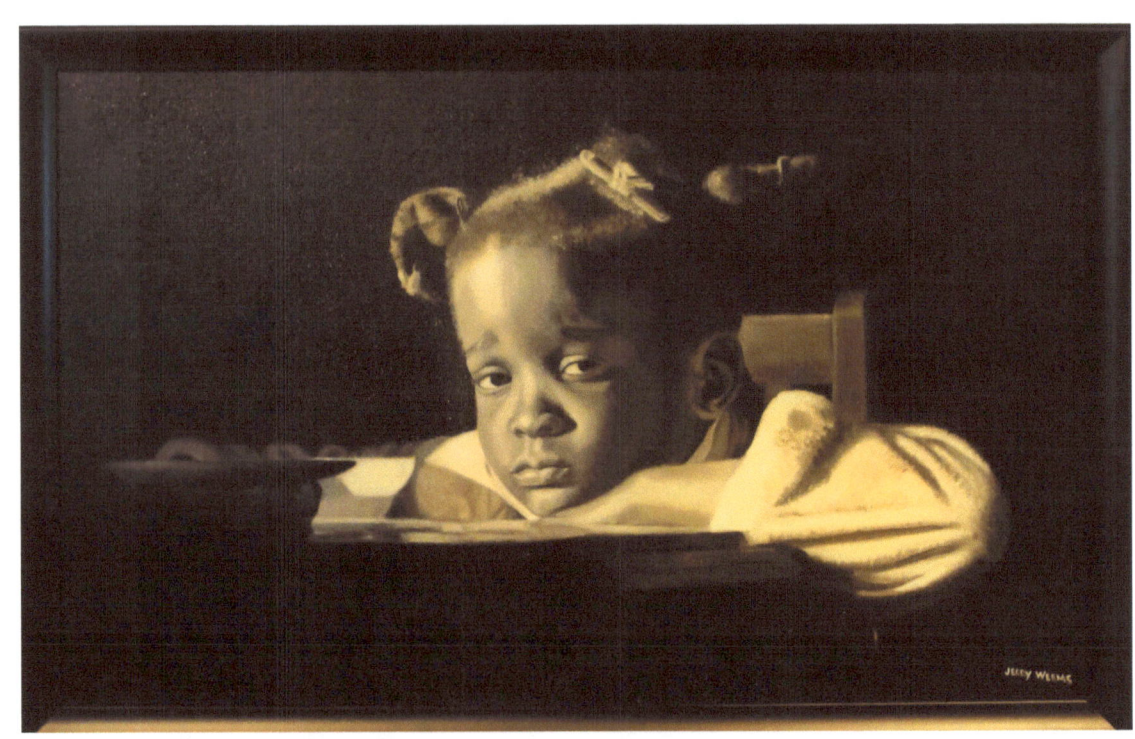

The disgruntle child 36"X48" oil on canvas

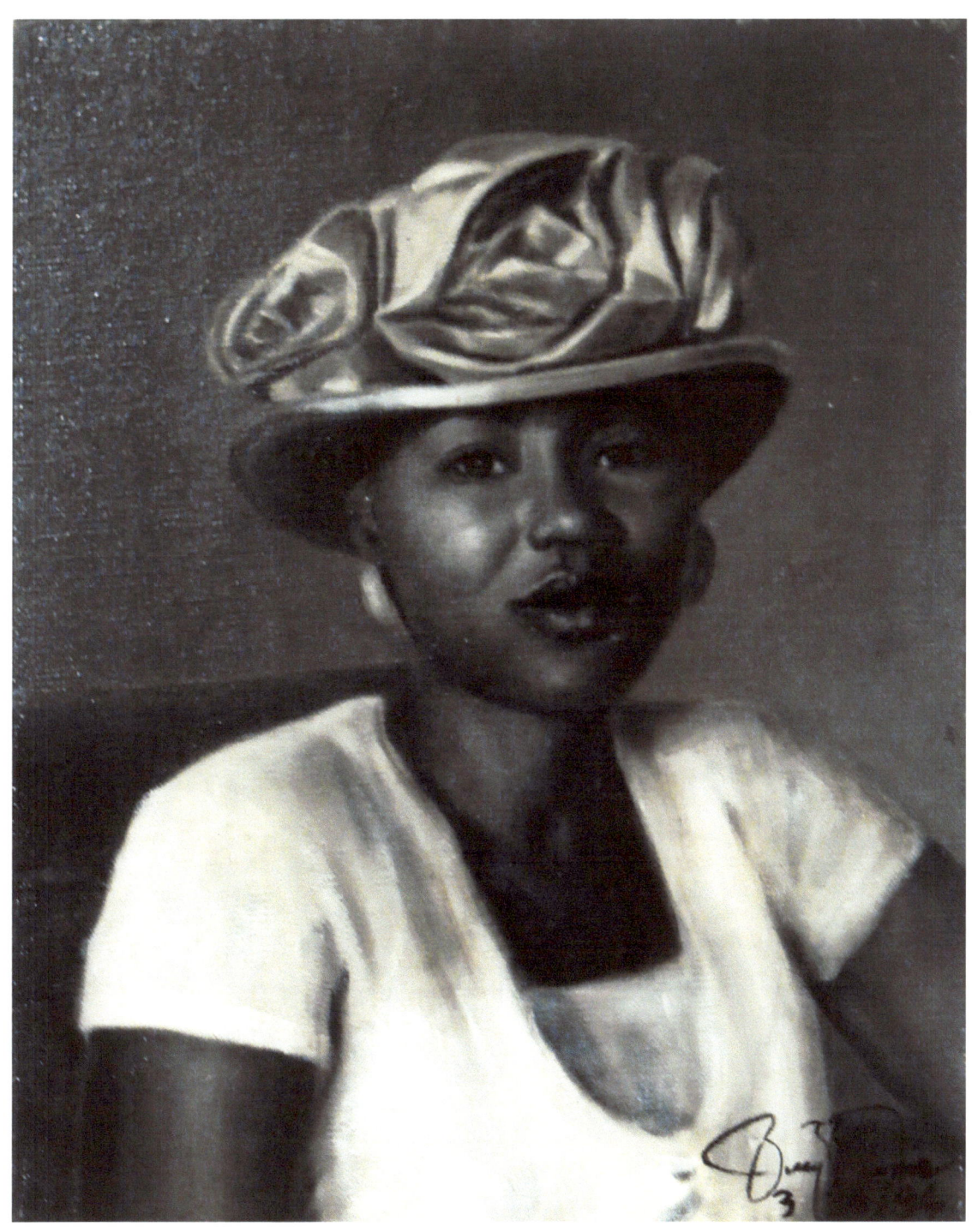

Lady in the hat 12"x16" oil on canvas

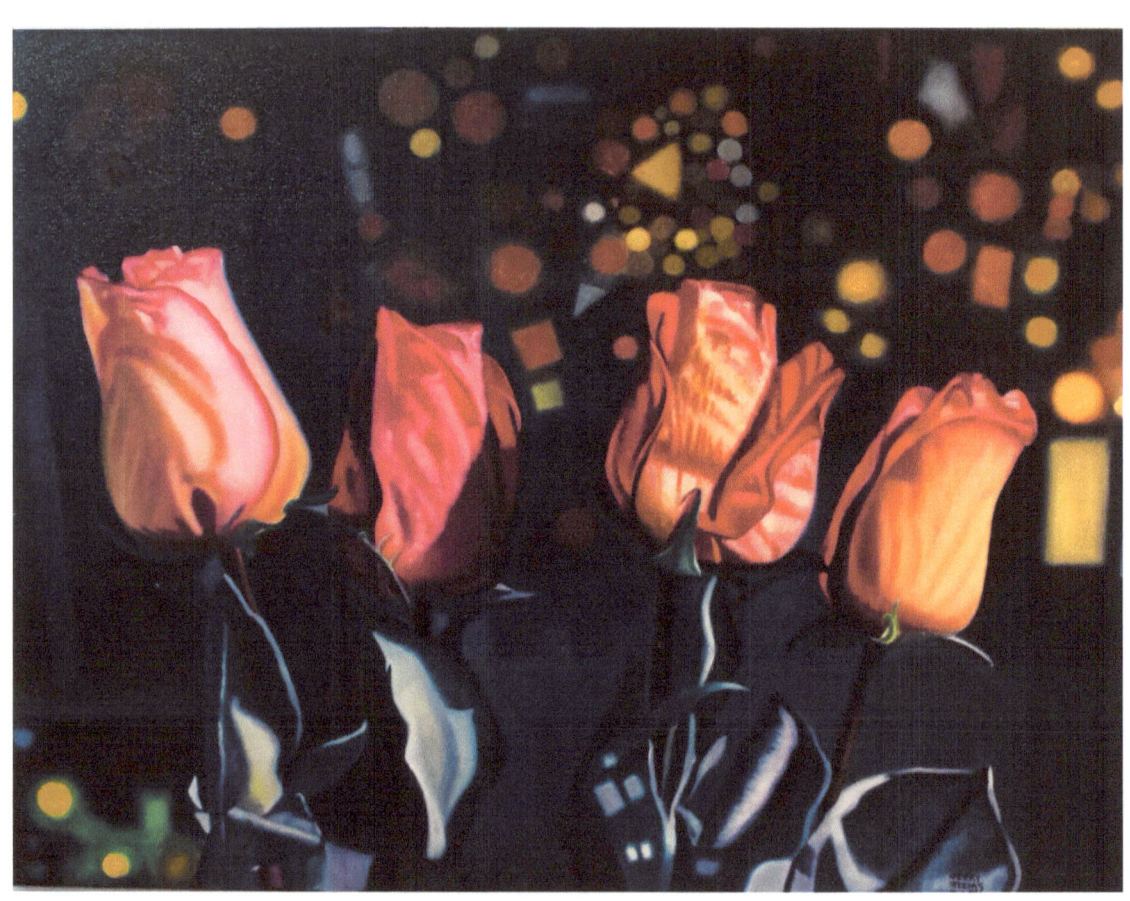

The four sisters 36"x48" oil on canvas

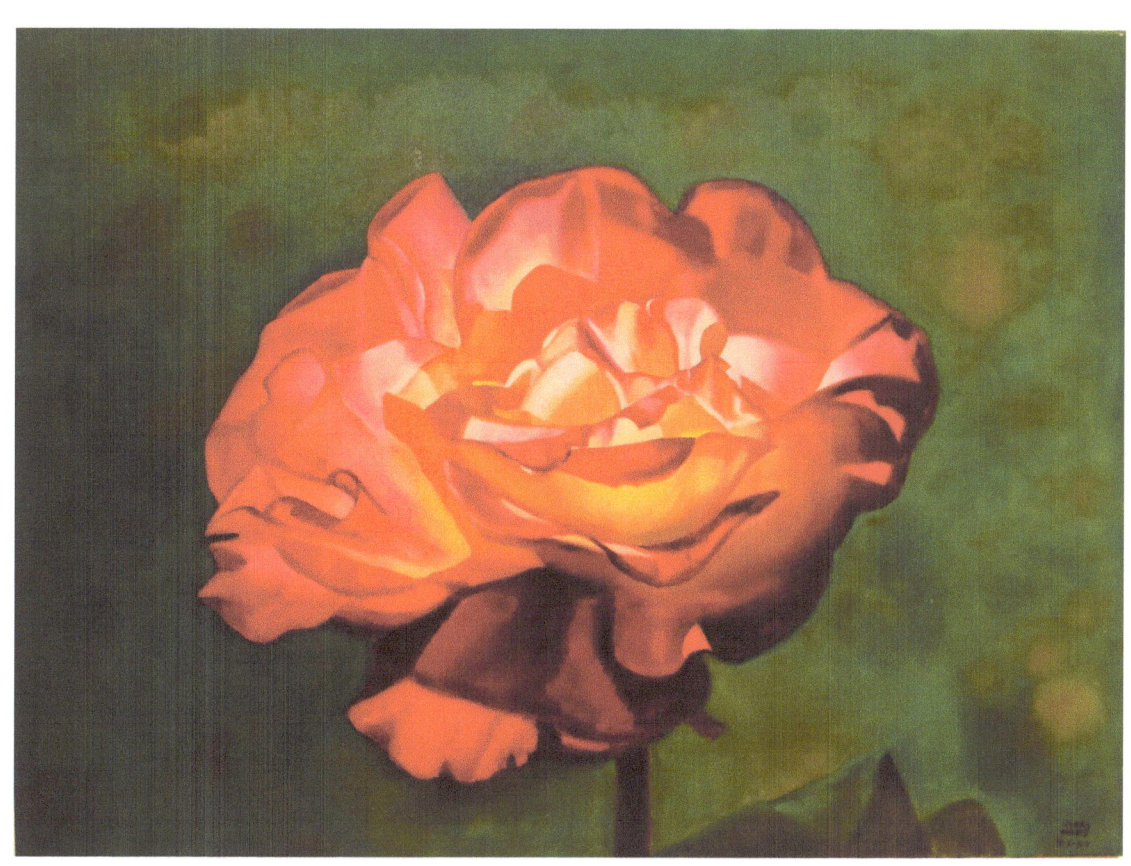

The rose 36"x48" oil on board

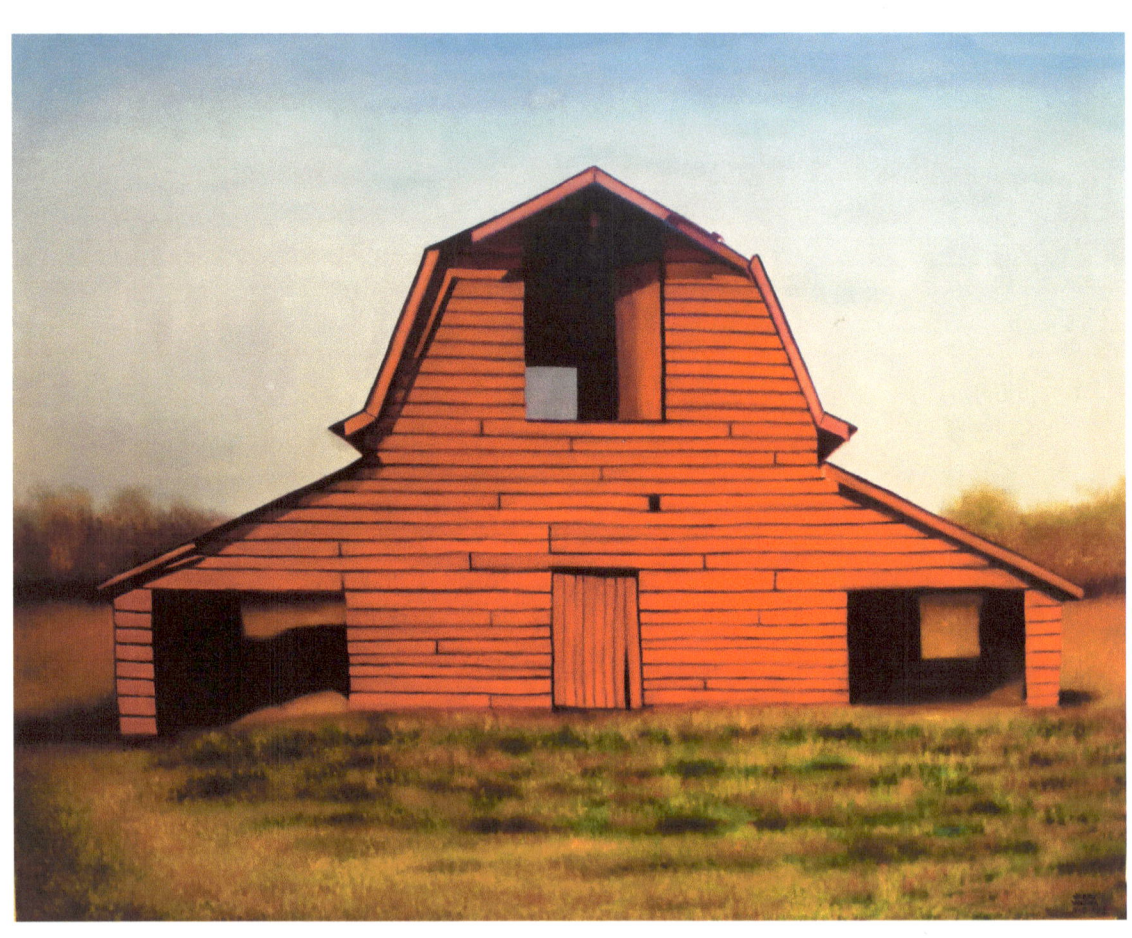

The red barn 48"x60" oil on canvas

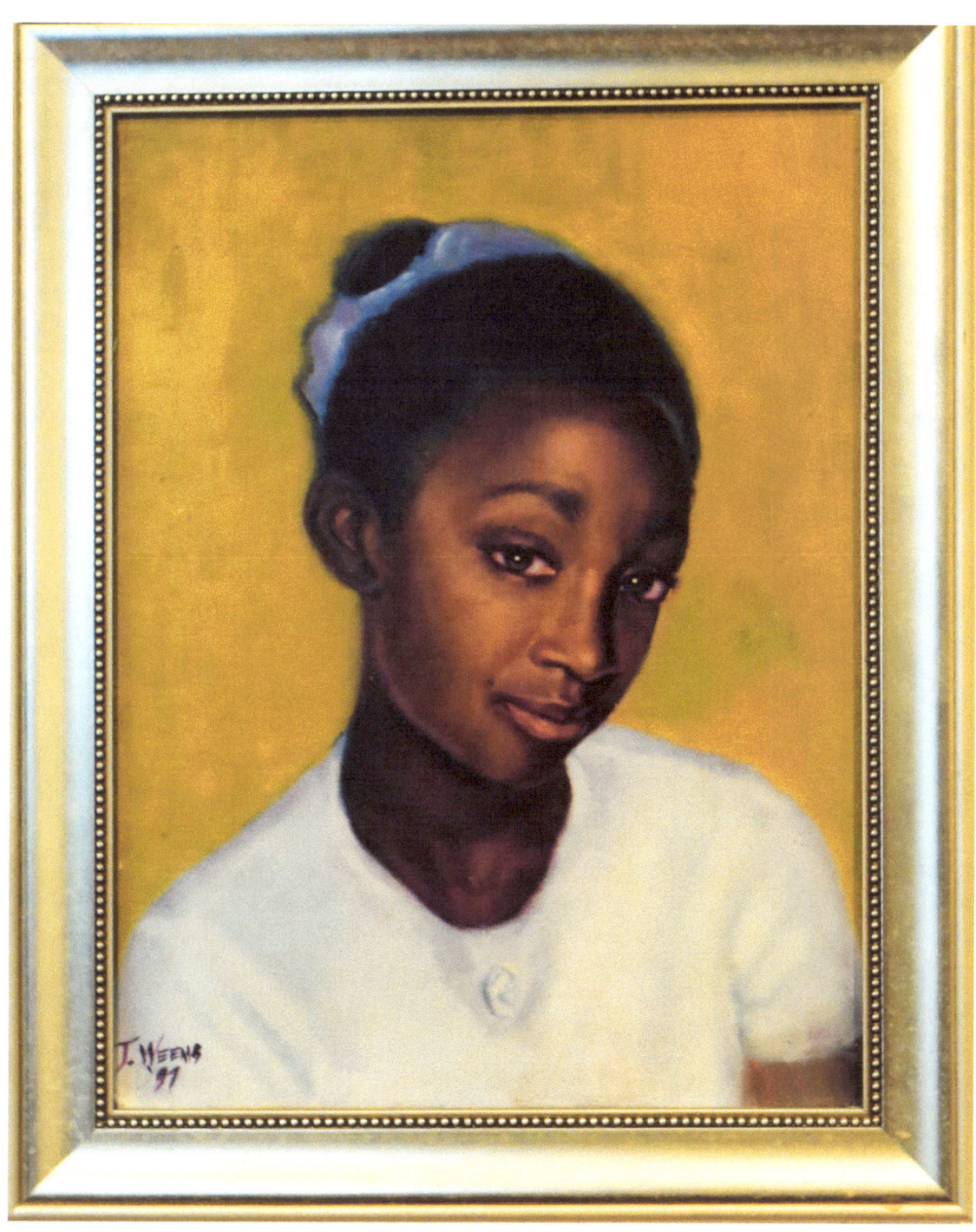

Artrice Weems 16"x24" oil on canvas

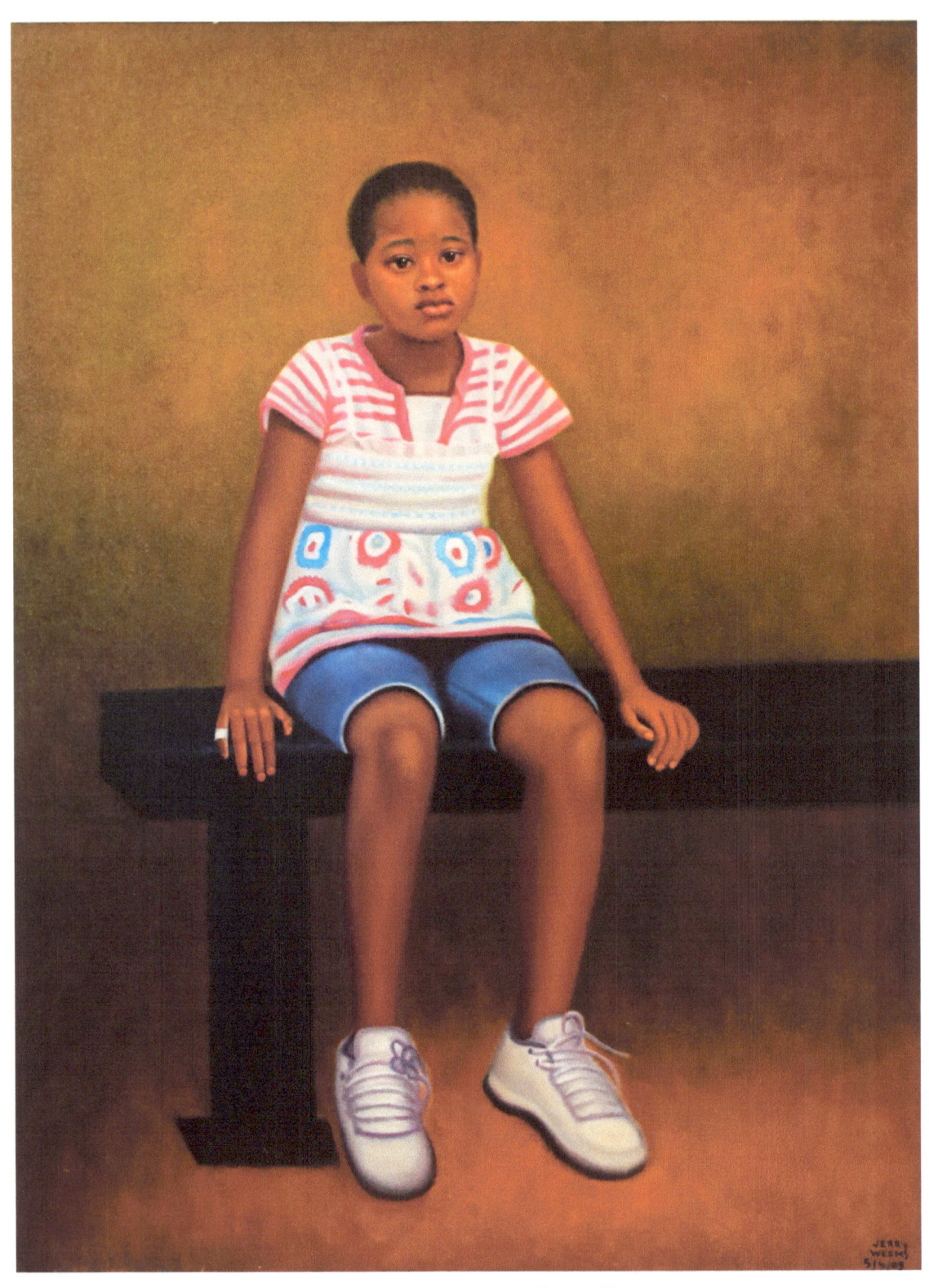

Girl with the untied shoes 36"x48" oil on canvas

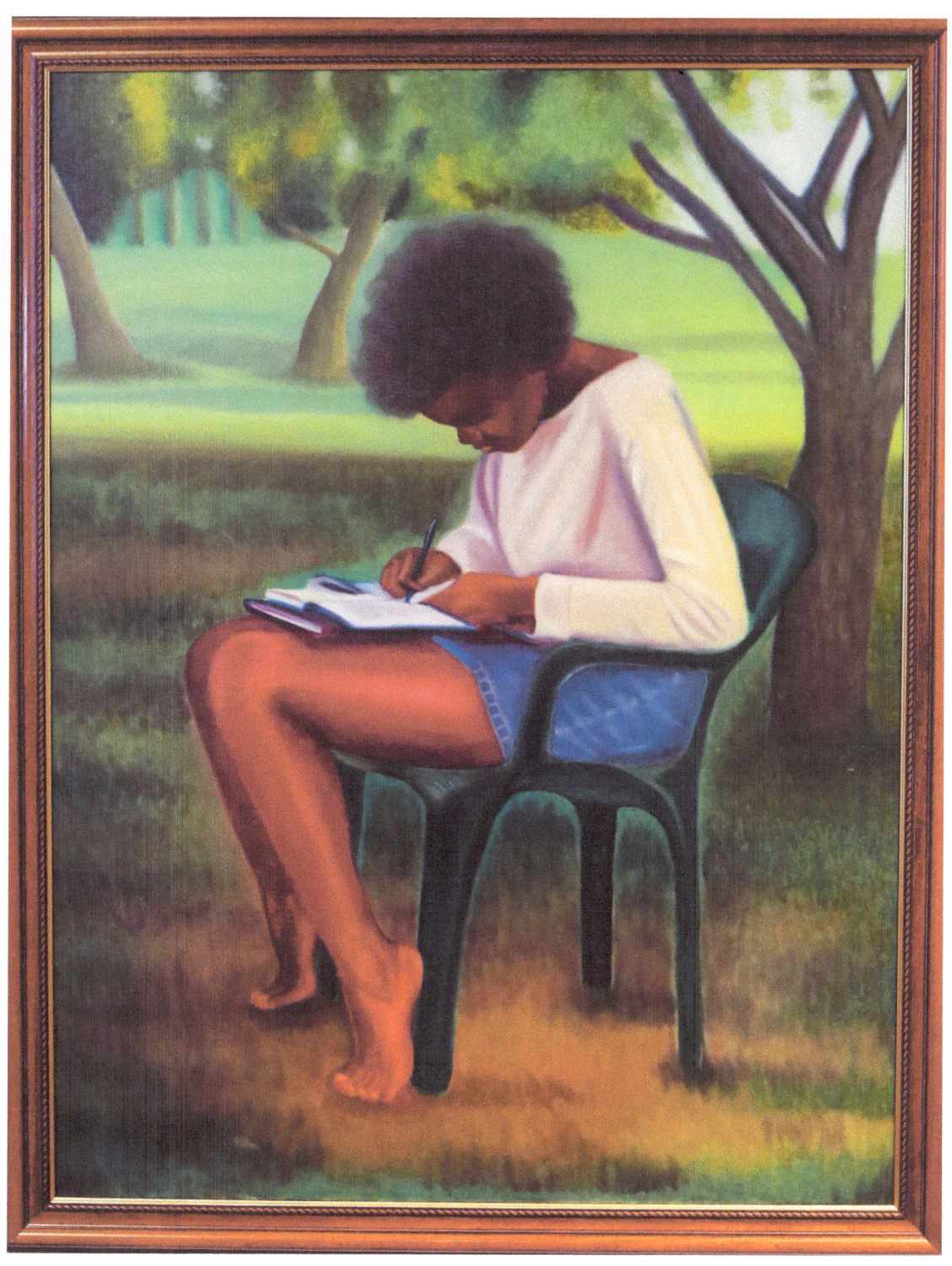

Girl studying under a tree 36"x48" oil on canvas

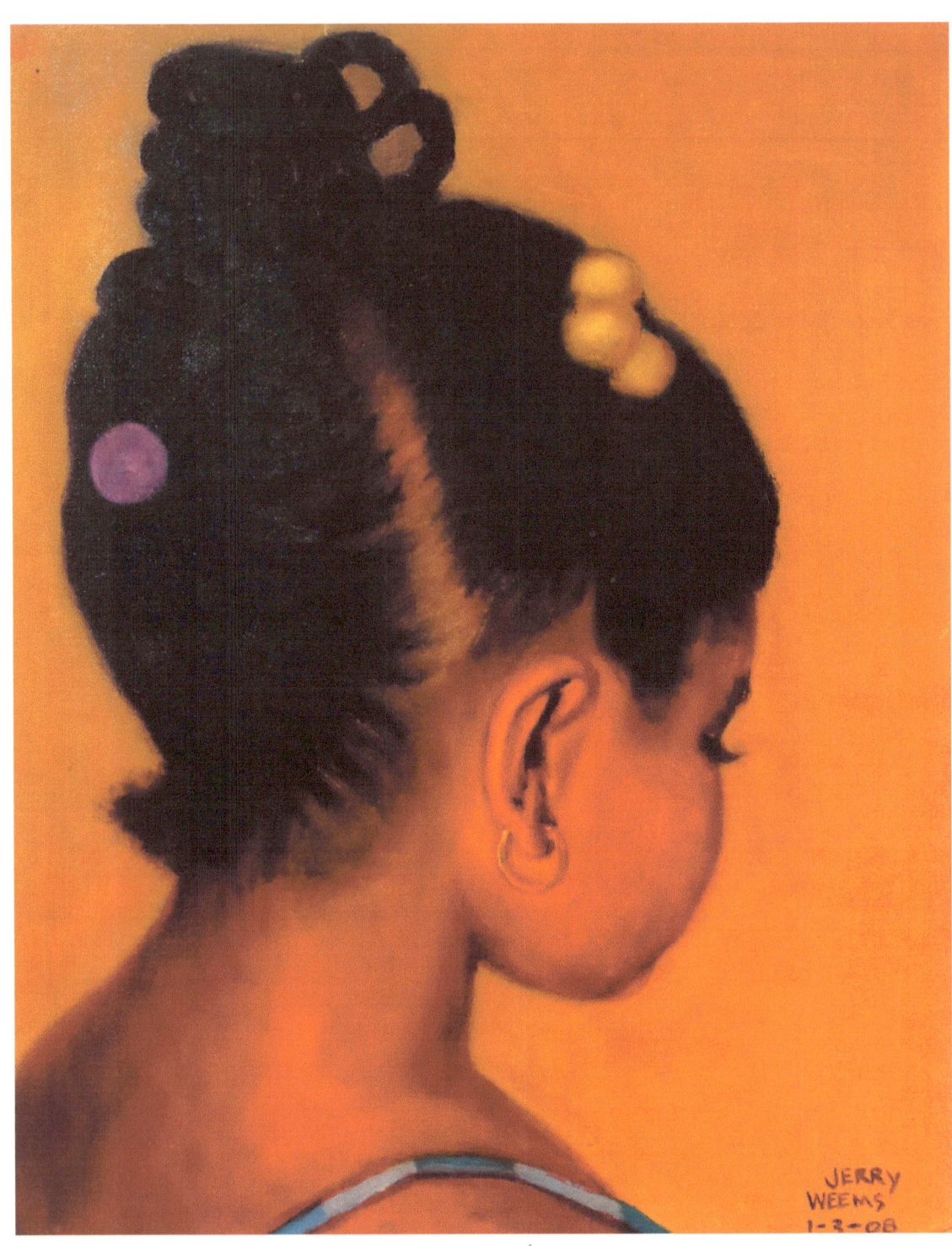

The study 12"x16" oil on canvas

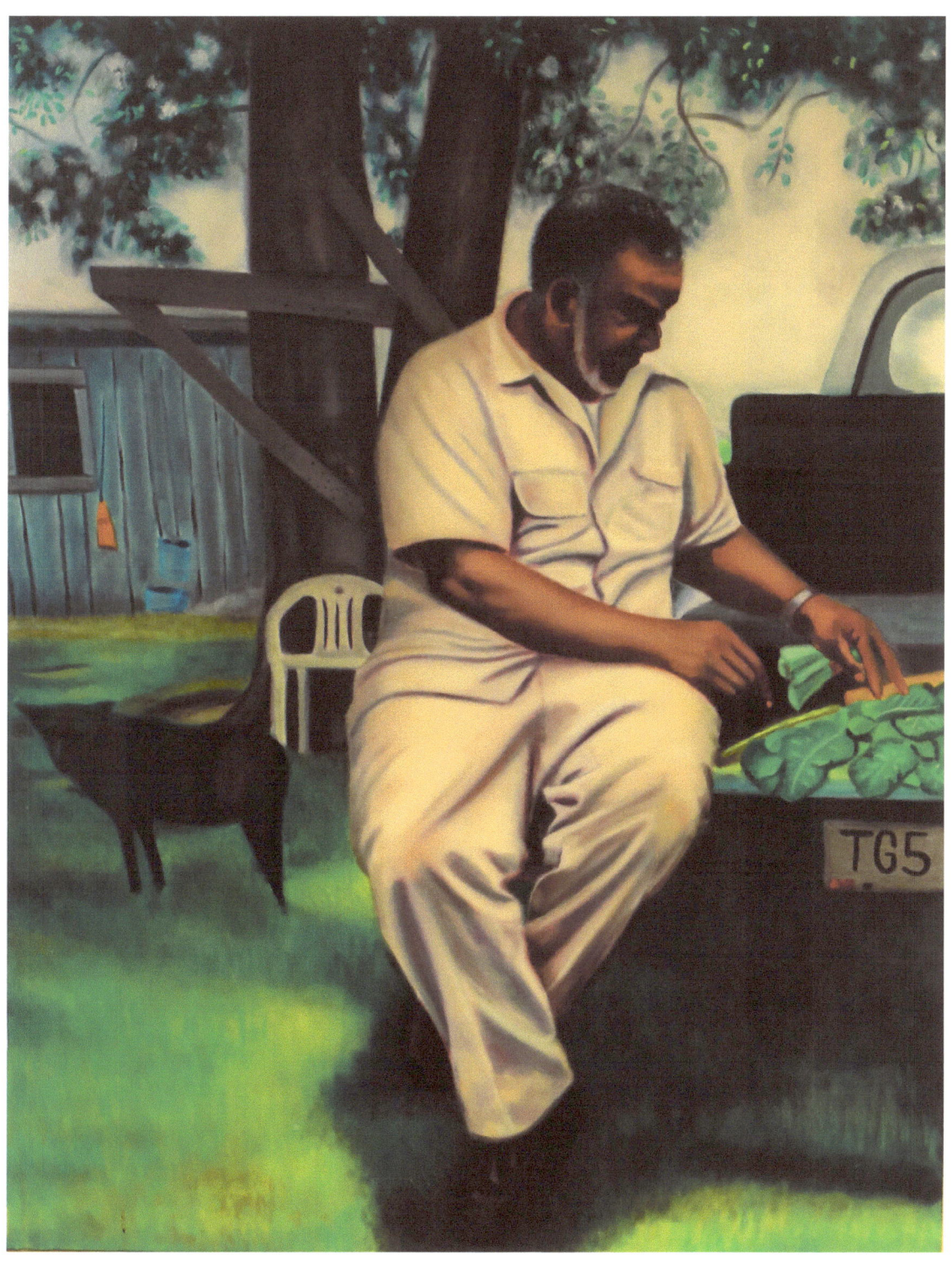

Picking collard greens 36"x48" oil on canvas

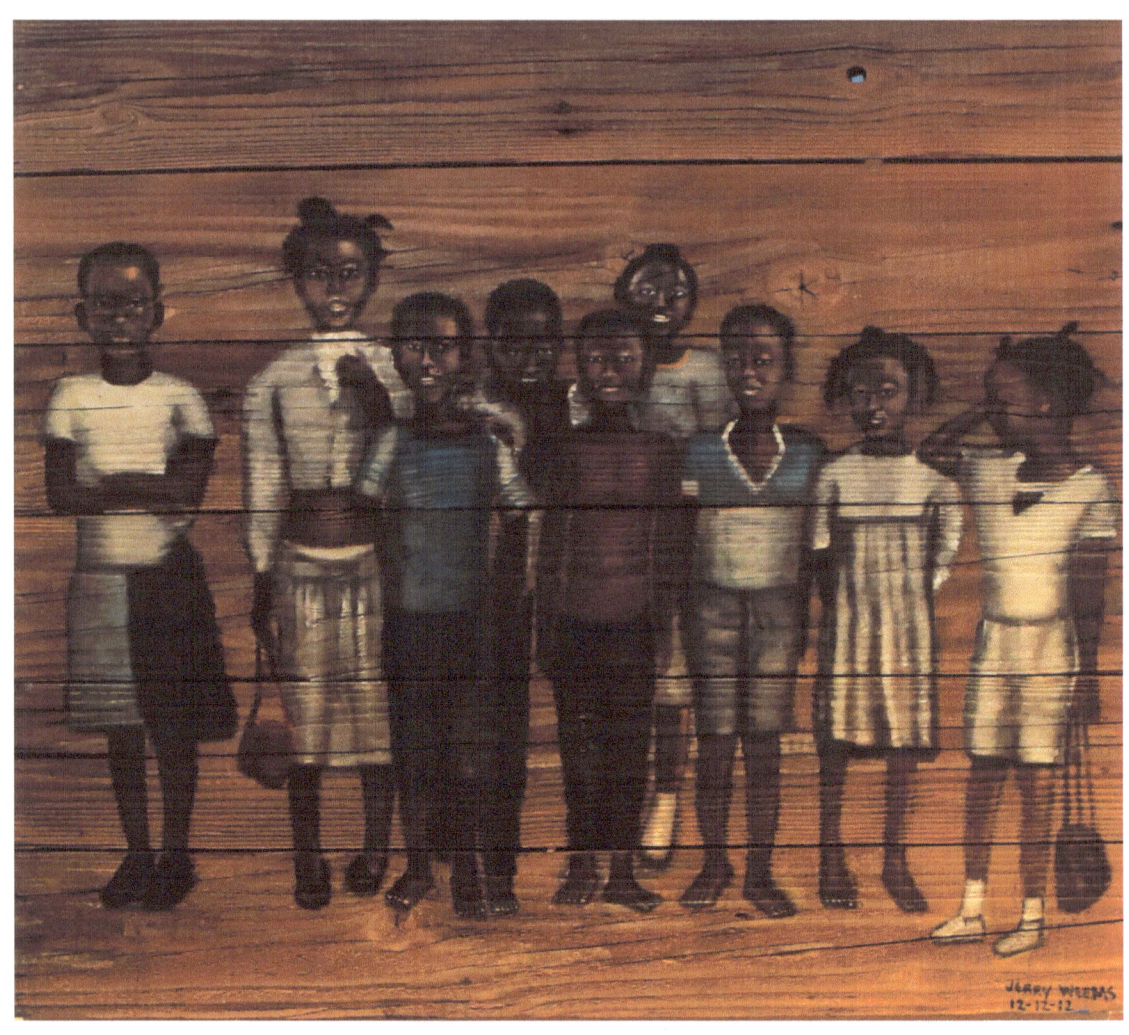

The kids down the road 36"x44" oil on wood

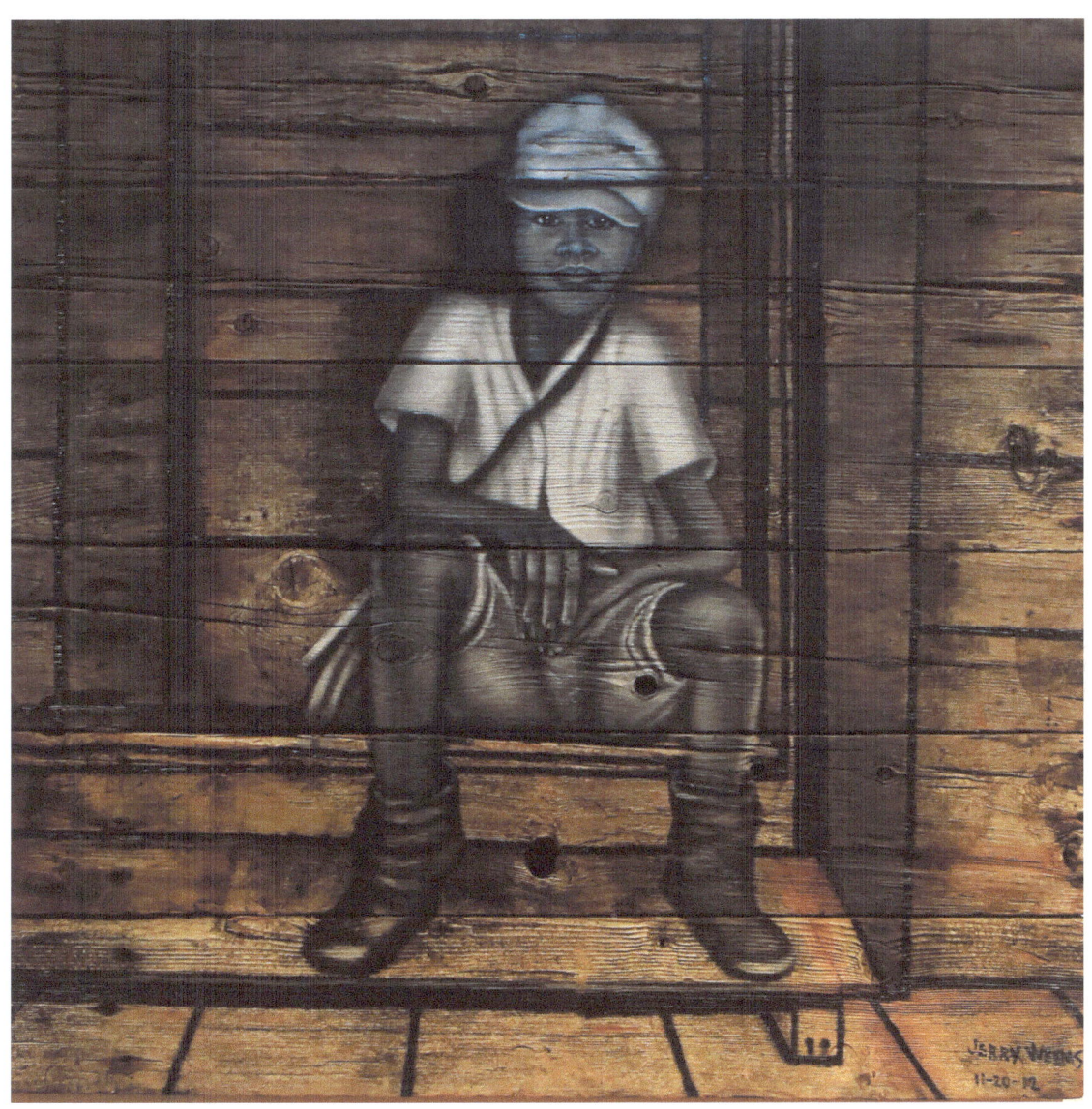

Girl sitting on the door step 42"x 48" oil on wood

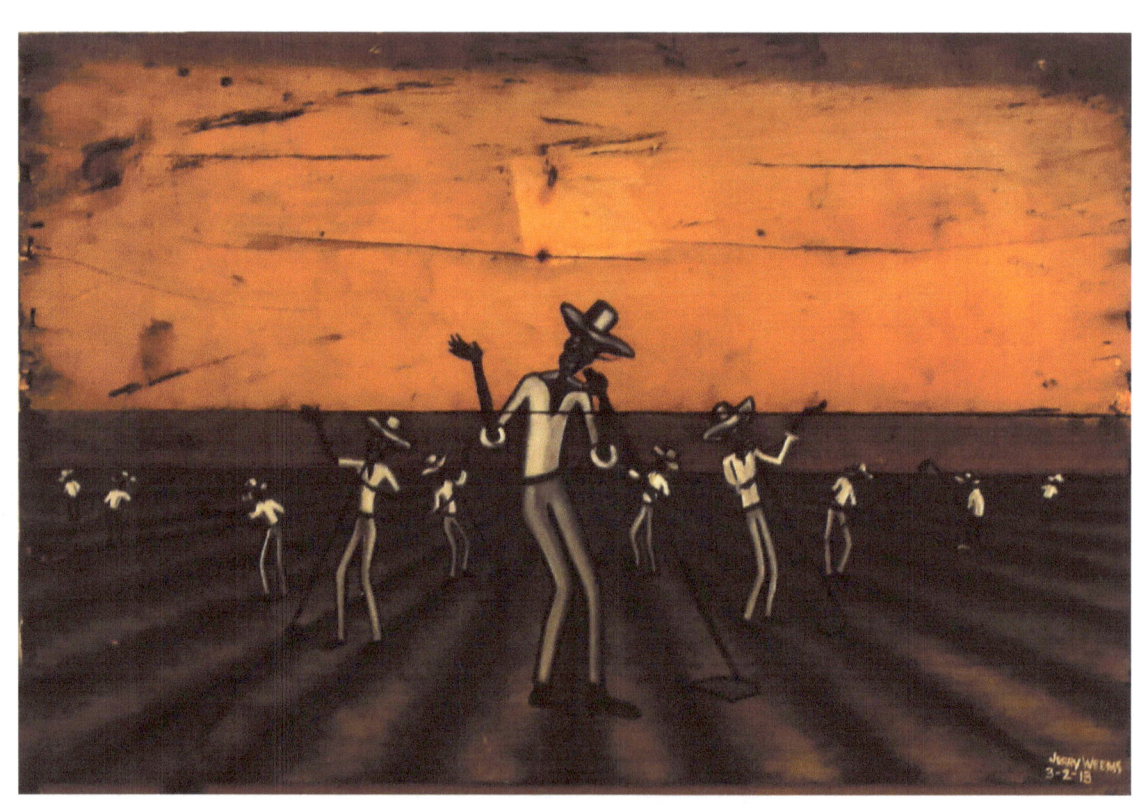

The chopping cotton blues 18"x24" oil on wood

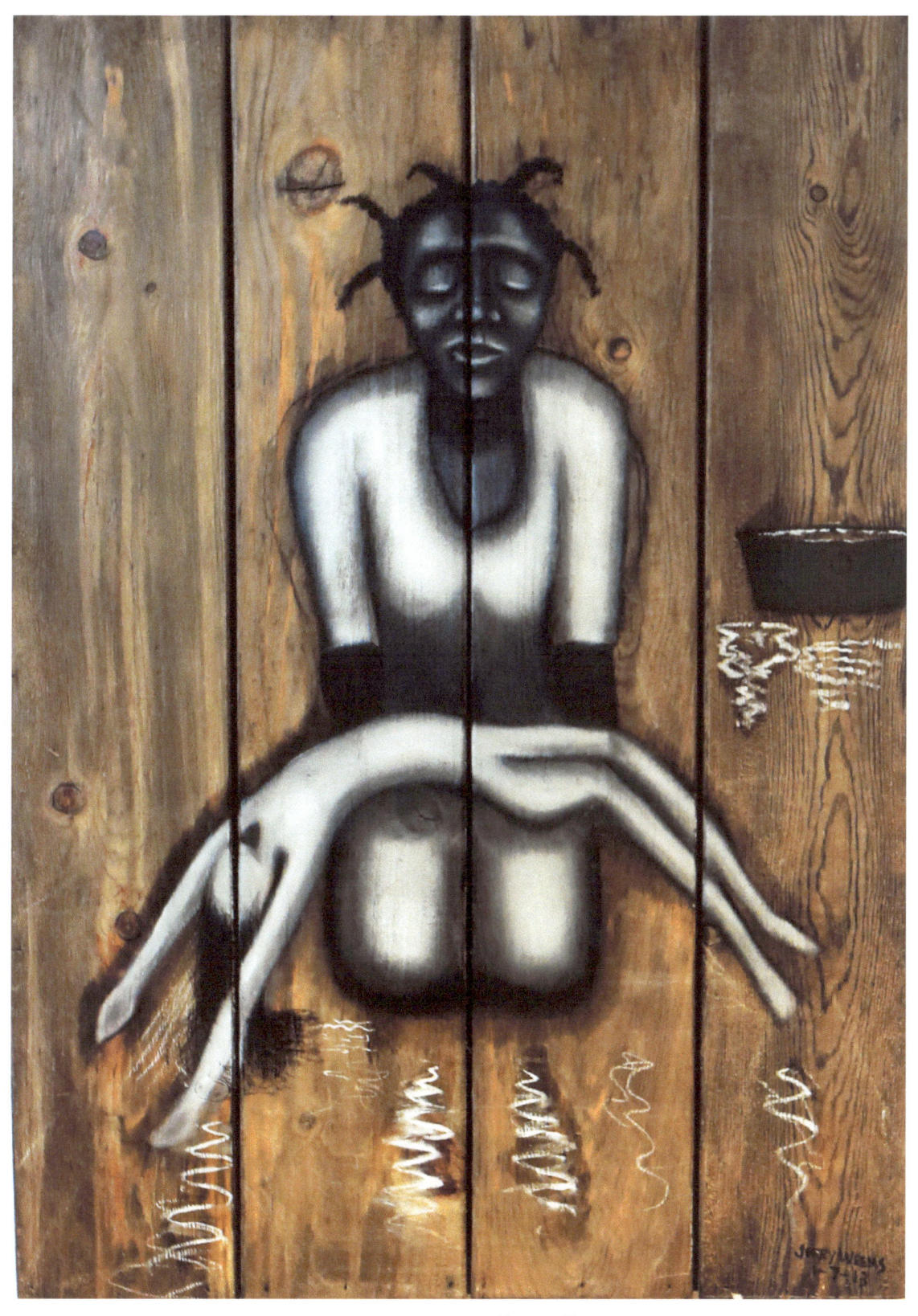

A form of resistance 21"x36" oil on wood

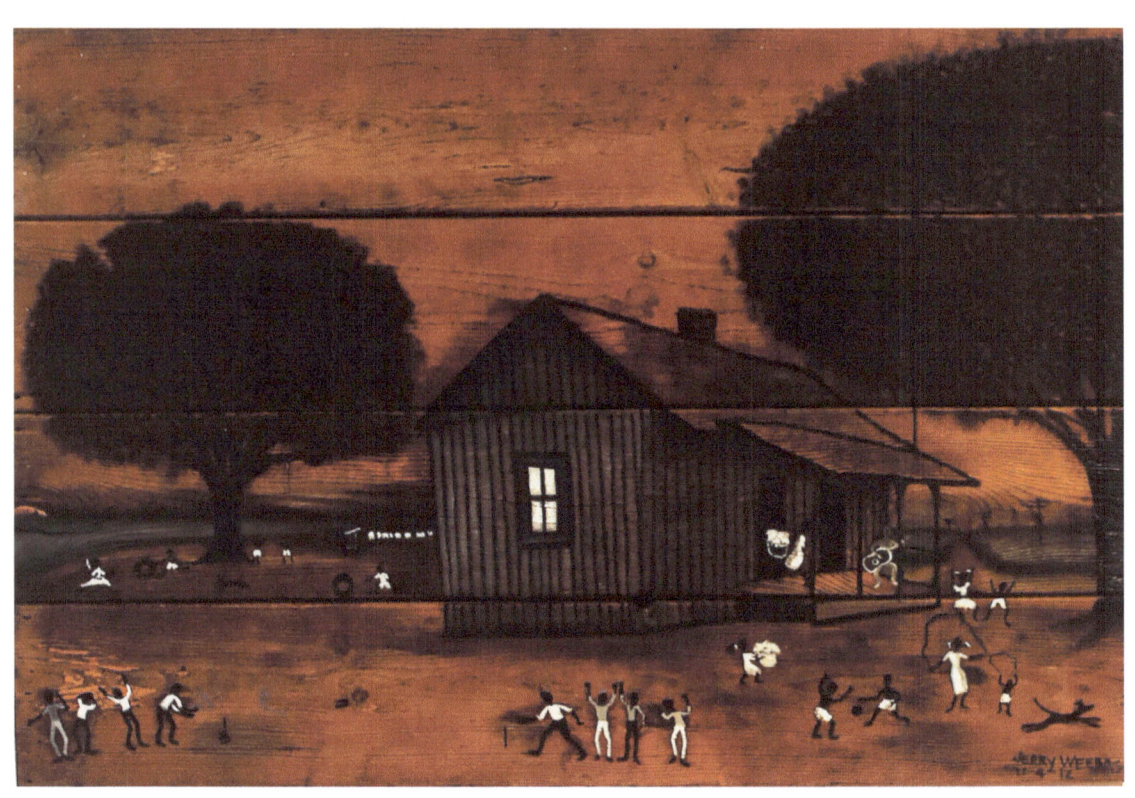

Playing horse shoes 21"x36 oil on wood

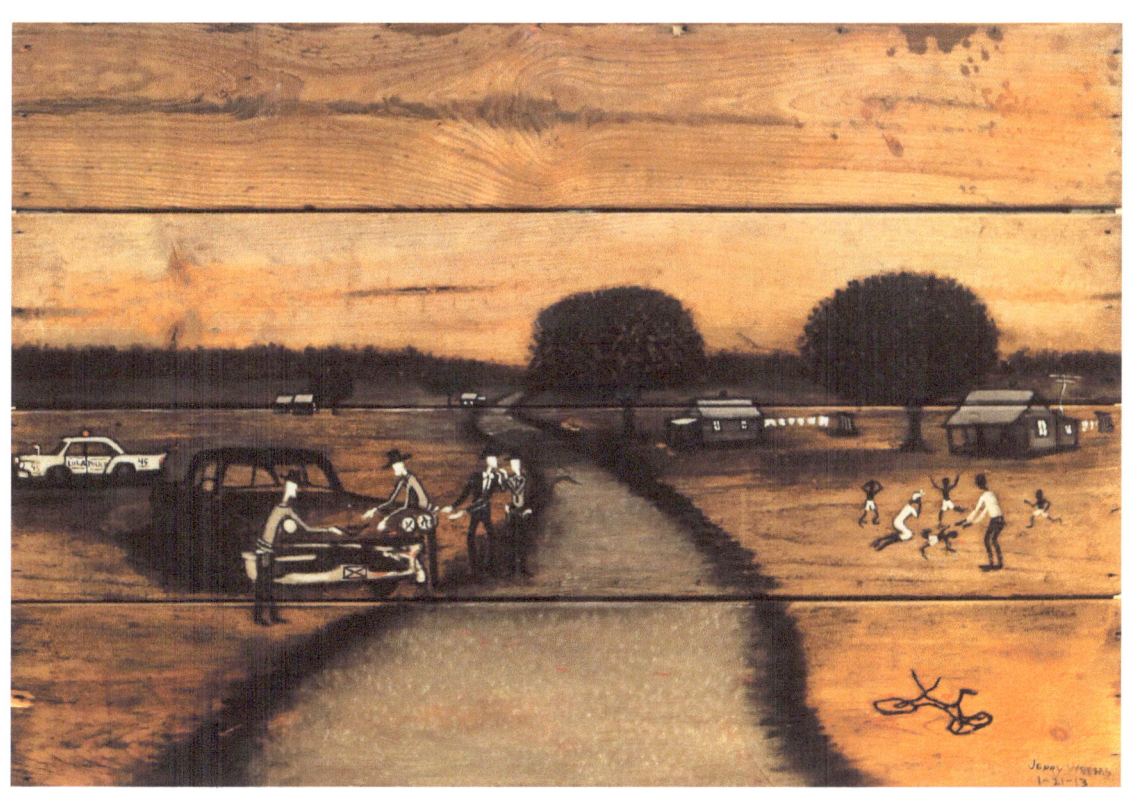
Tow truck is on its way 21"X36" oil on board

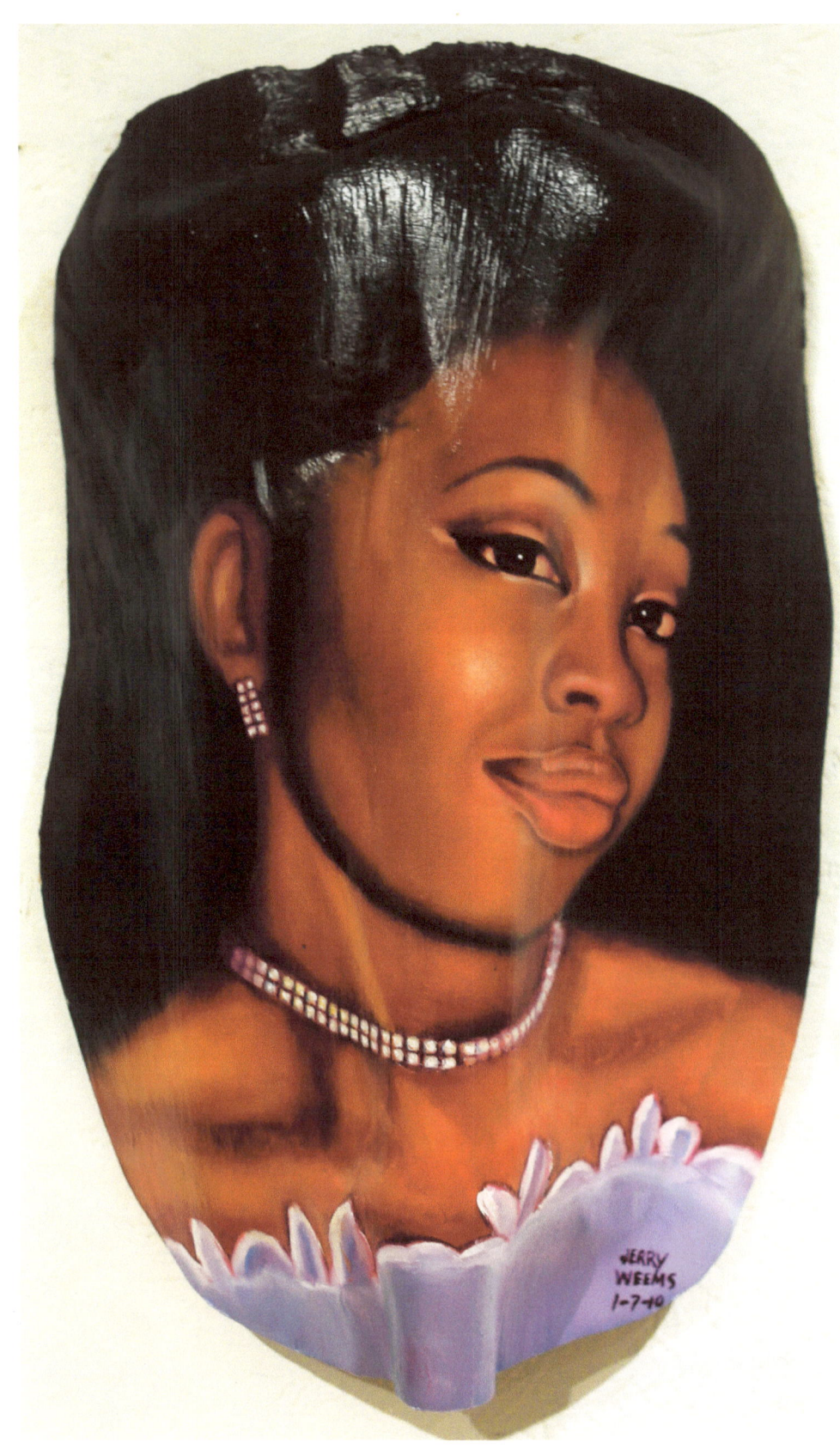

Marissa 15"x 37" oil on palm frond

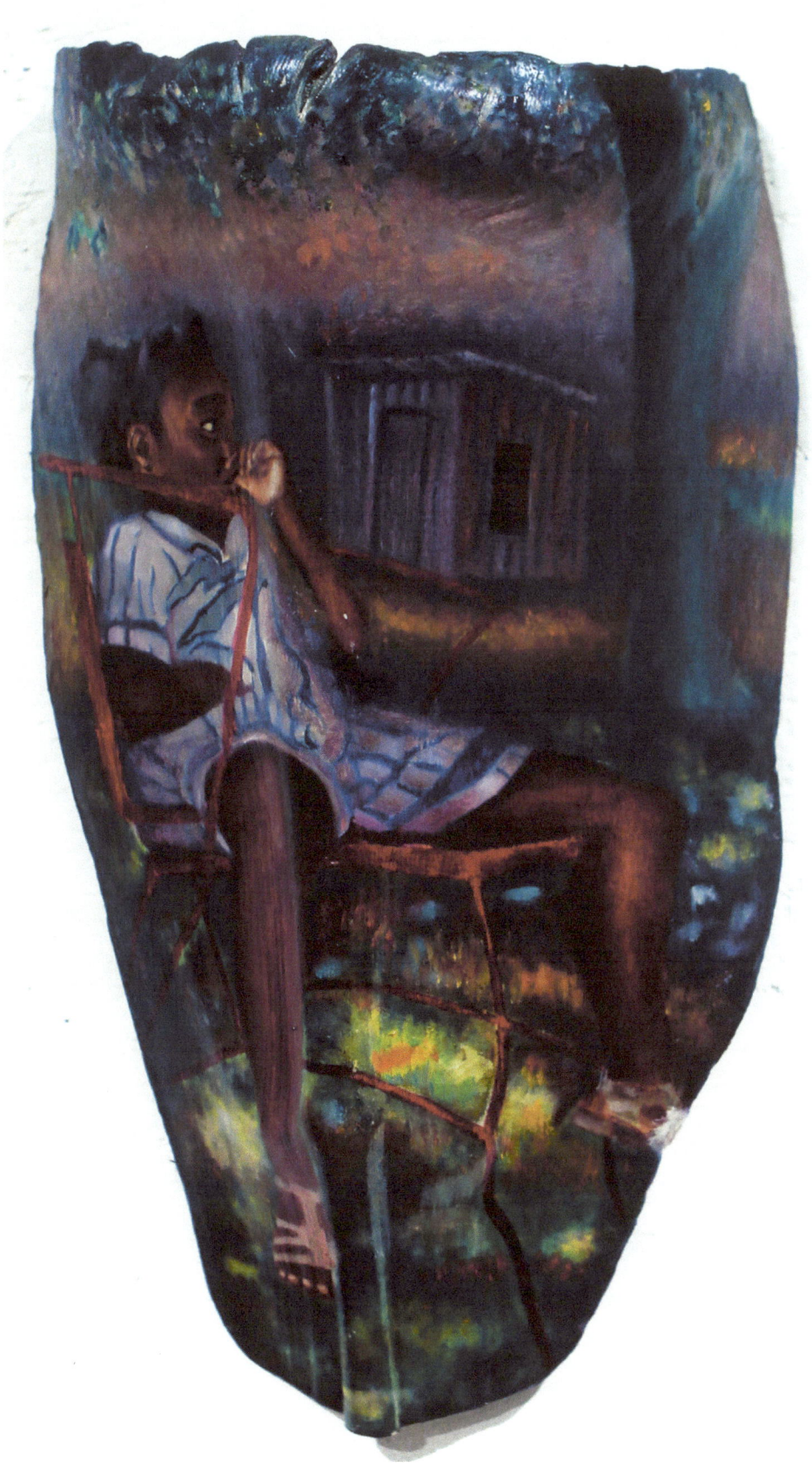

Under the shade tree 15"x 20" oil on palm frond

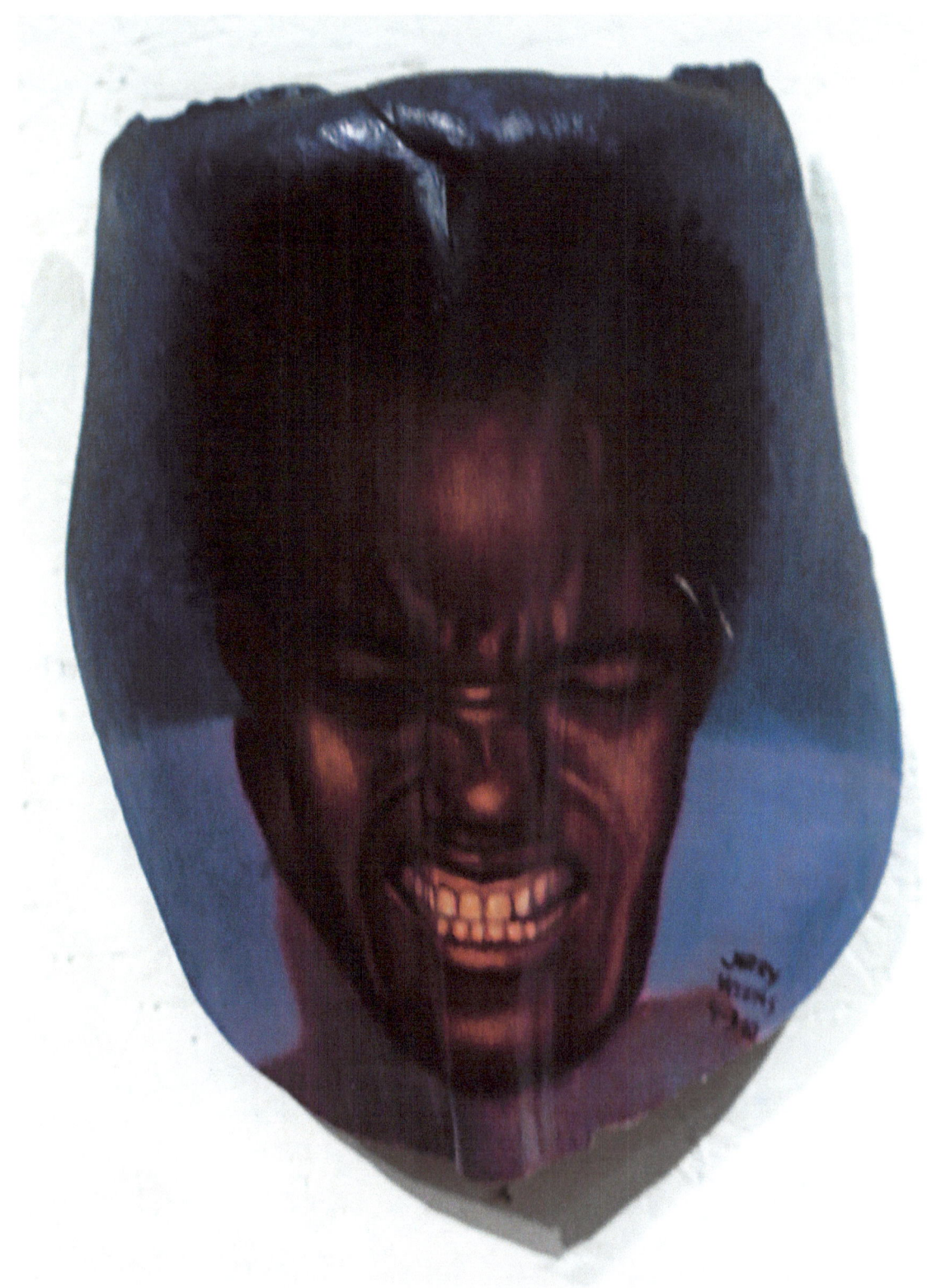

HELP!! 12"X 16" oil on palm frond

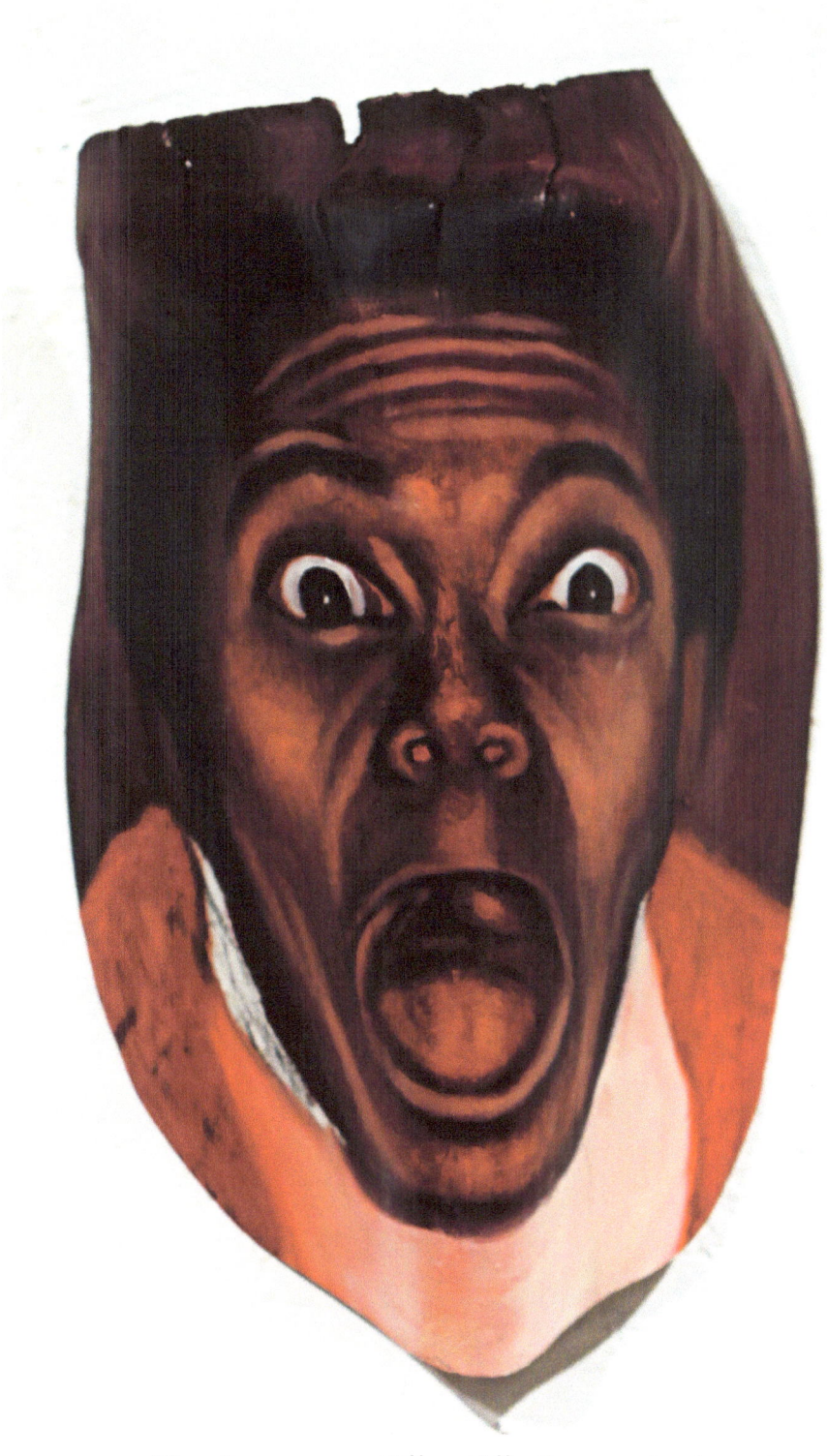

Silent scream 12" x 16" oil on palm frond

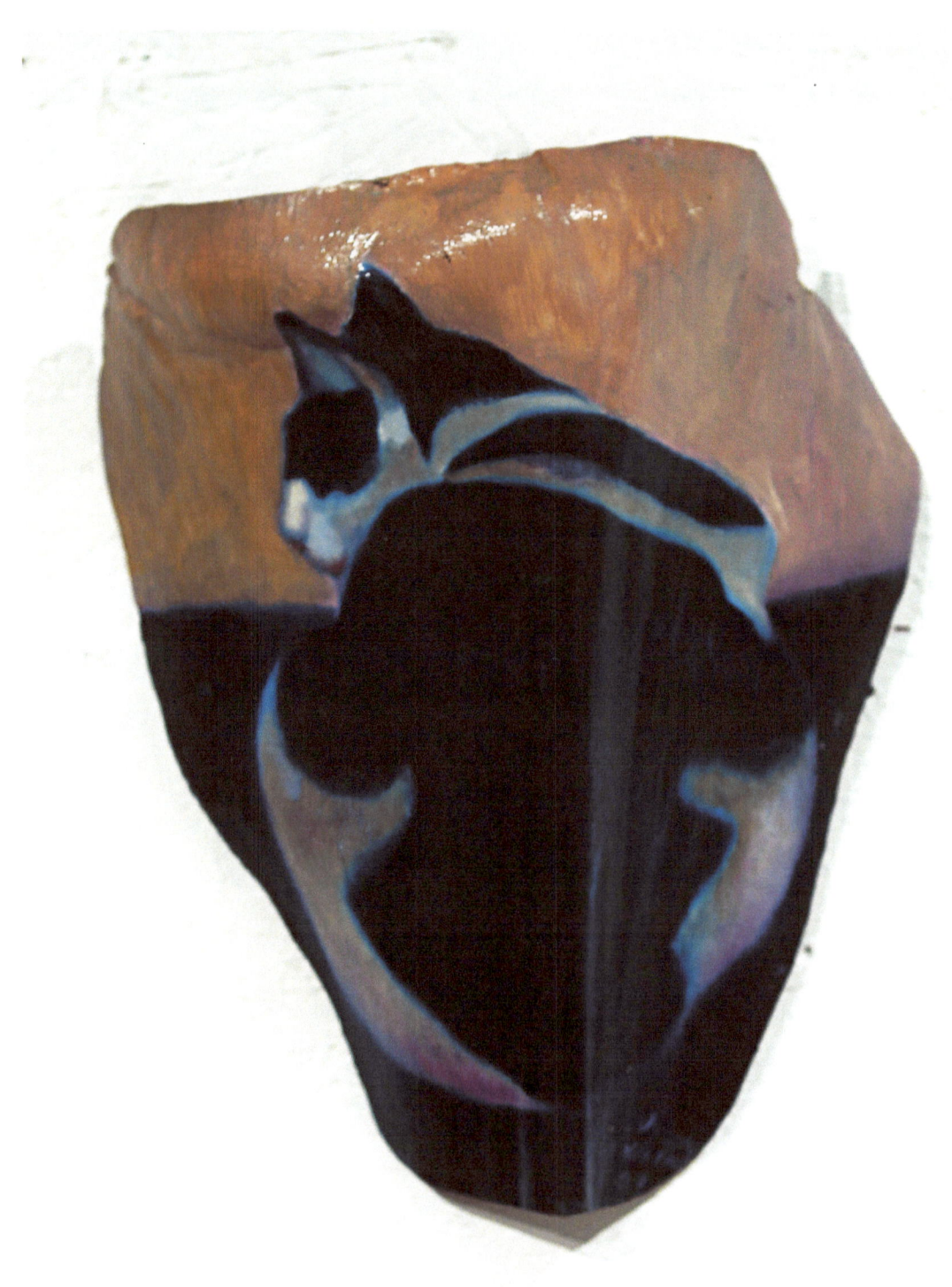

Cat's back 12" x 16" oil on palm frond

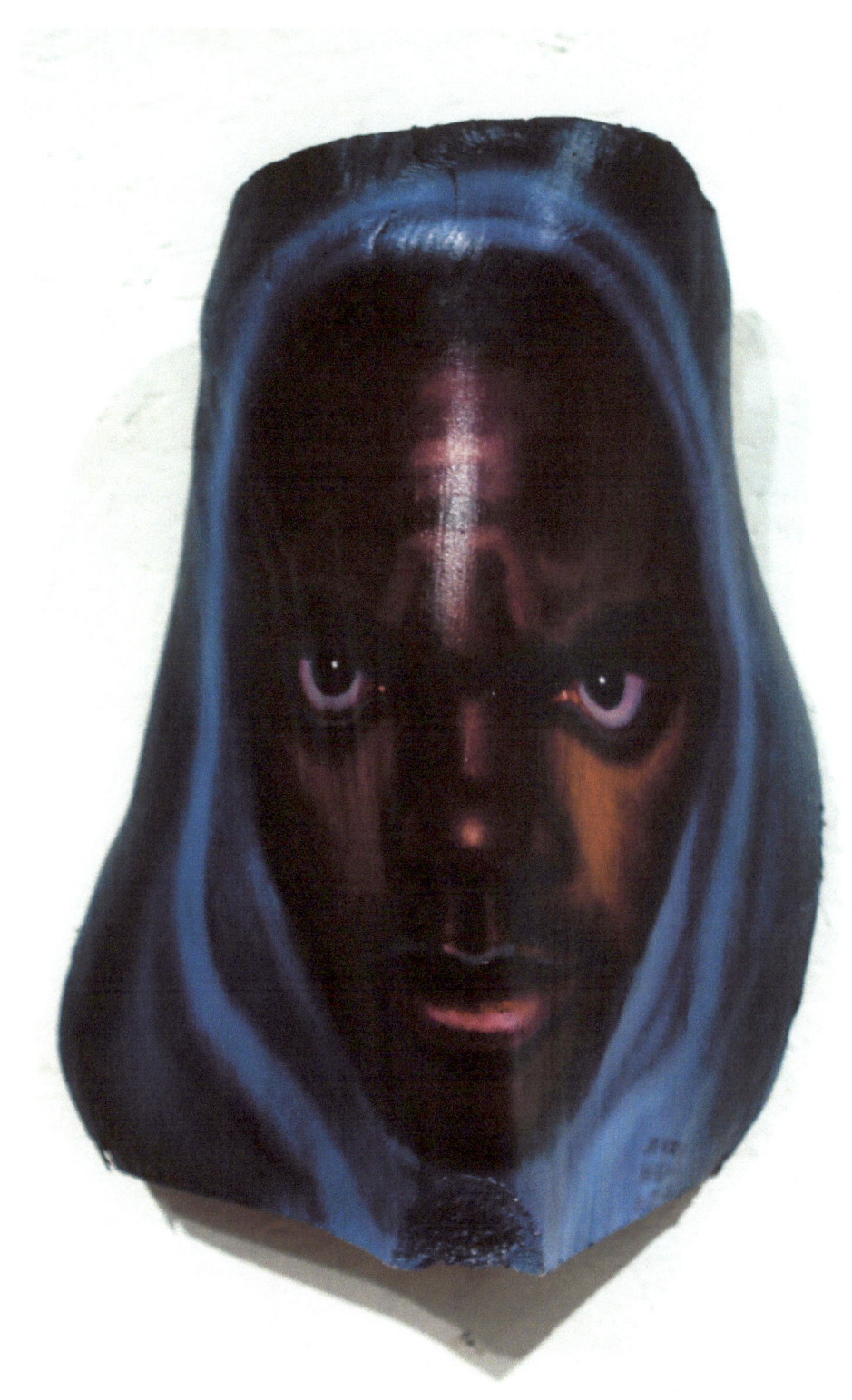

Young Christian kid in a hoody 13" x 16" oil on palm frond

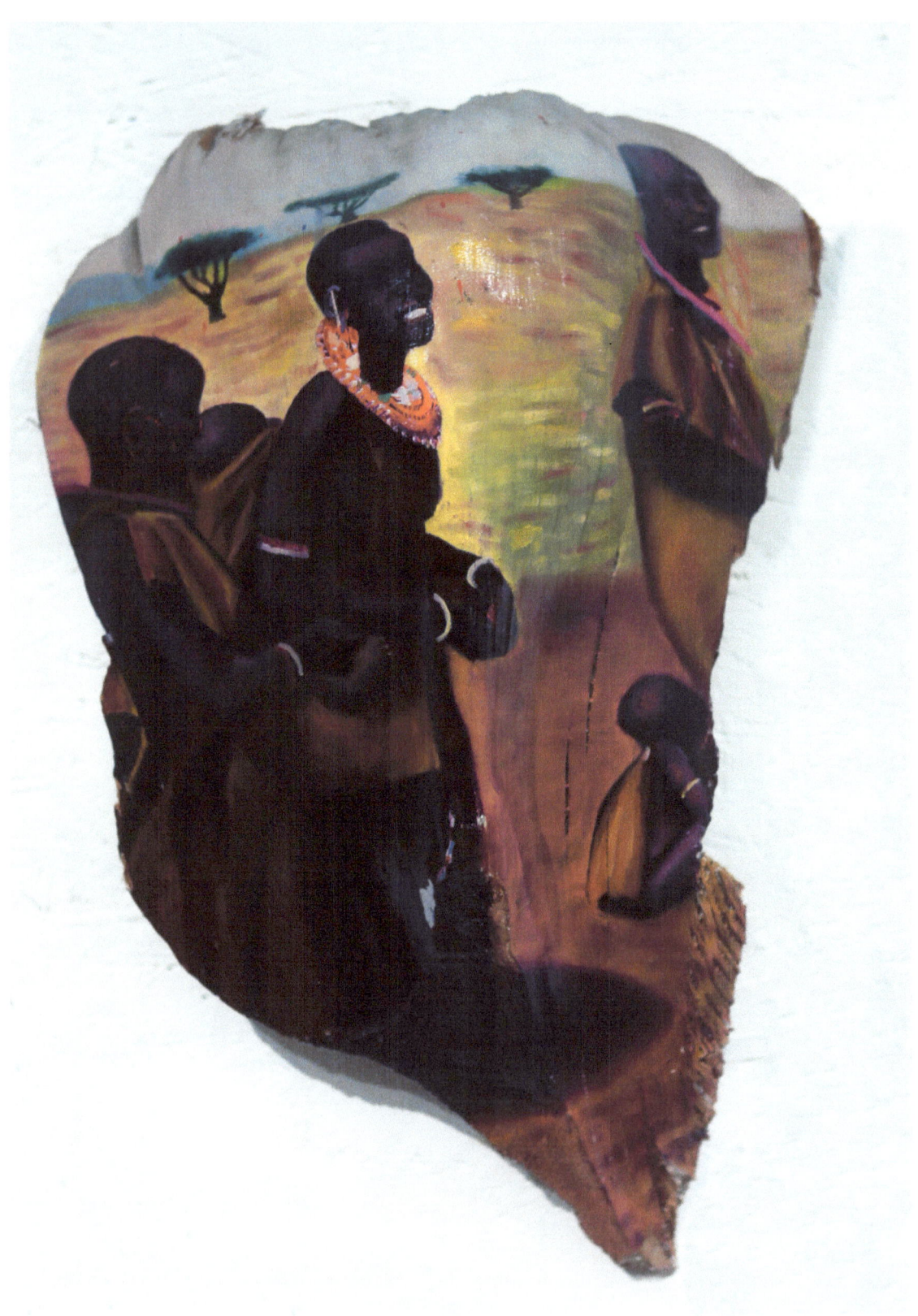

Strolling 12" x 18" oil on palm frond

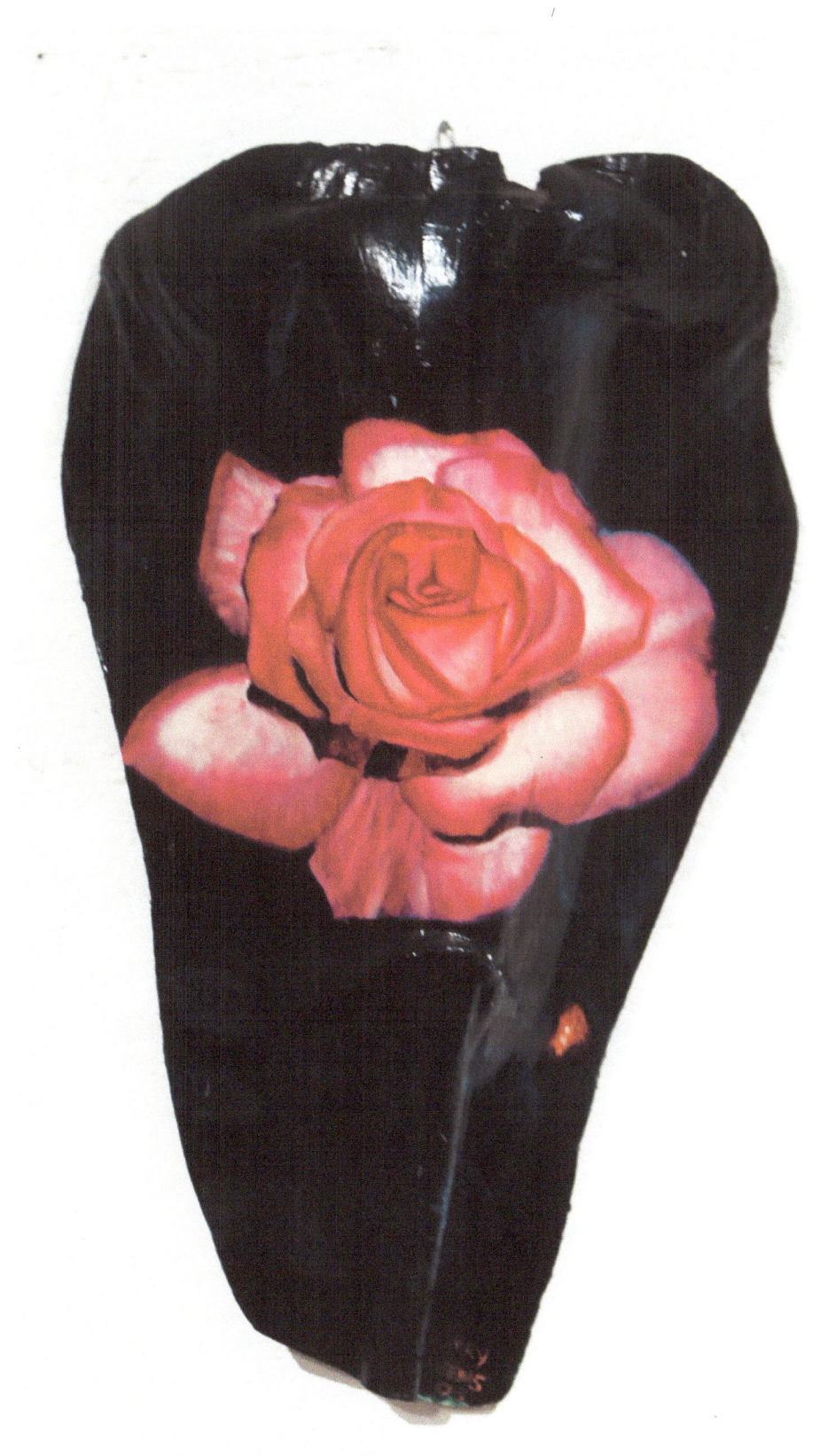

The red and white rose 15" x 25" oil on palm frond

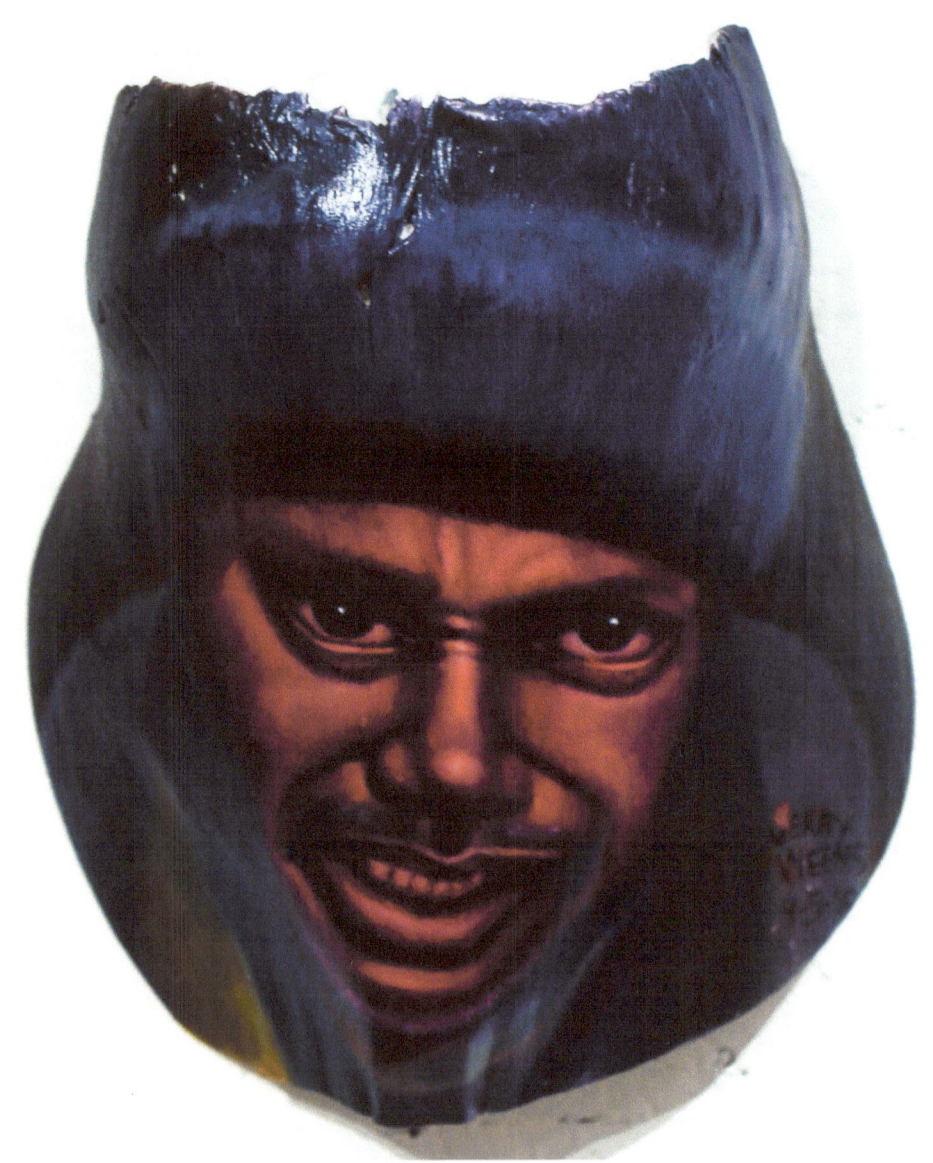

Archie 12" x12" oil on palm frond

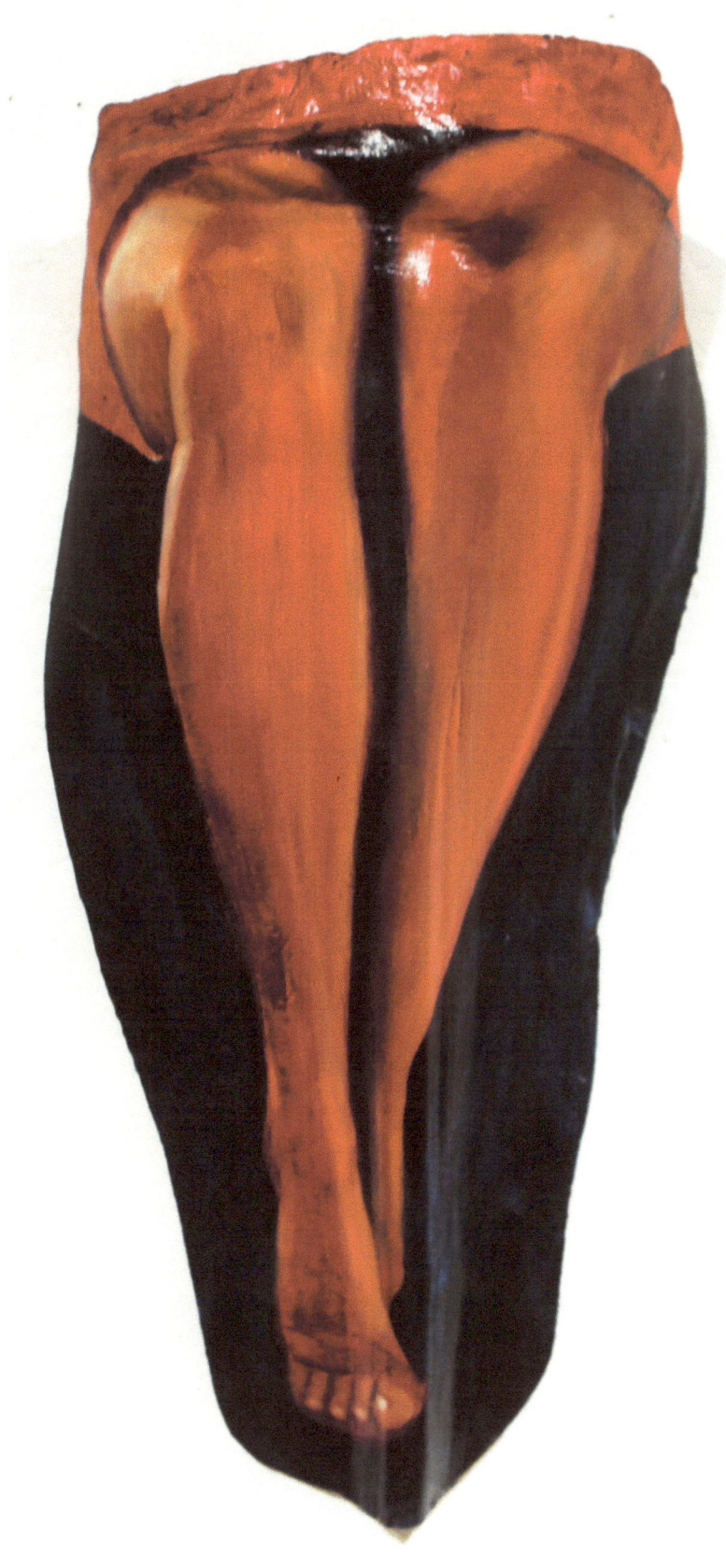

Legs 25" x 46" oil on palm frond

www.ingramcontent.com/pod-product-compliance
Lightning Source LLC
Chambersburg PA
CBHW050808180526
45159CB00004B/1597